Tradition Transformed
Tibetan Artists Respond

ARTASIAPACIFIC

Tradition Transformed
Tibetan Artists Respond

ARTASIAPACIFIC

RUBIN MUSEUM OF ART
NEW YORK

Founder's Statement

Shelley and I bought our first traditional thangka painting in 1975. This was the first step on a journey that led to the opening of the Rubin Museum of Art in October 2004. But the journey has not ended there. Collecting and preserving the art of the Himalayas, the secluded mountainous area of south-central Asia, is one of my passions, and it continues unabated by time or the great success of the museum.

A little more than four years ago I saw my first contemporary works created by artists from Tibet, Nepal and Bhutan—some who are still living in the region and others who are now in the diaspora. It was a start of a new love affair. Shelley and I remain captivated by traditional Tibetan art, but our strict fidelity to the classical form has loosened.

Our contemporary Himalayan art collection, which now numbers more than 250 pieces, includes painting, sculpture, photography and mixed-media work. We mounted a successful exhibition of a small number of these artworks at my alma mater, Oglethorpe University in Atlanta, in January 2009. But much of the art in "Tradition Transformed" at the Rubin Museum of Art comes either from our collection or from other private collections, and has never been exhibited. In fact, some of the most compelling pieces have been created by the artists expressly for this exhibition. Many of these works have elements of more familiar traditional art, but the artists have transformed them into fresh means of expression, revealing their sophisticated understanding of their historical backgrounds and their position on the cusp of what may be a new contemporary art form.

—*Donald Rubin*

Preface

My experience studying the arts of Tibet is likely shared by most of my colleagues in the field. Our expertise lies in the ancient arts and material culture of the Buddhist world. Only in the last ten years has scholarship expanded to also embrace contemporary artworks as they gain increasing attention and begin to enter the mainstream of the art world.

Tibet's contemporary art movement can be understood as a distinct consequence of its recent political history. Tibetan art was always created in the service of Buddhism and the region's religions. After the Communist Party of China began to severely repress the practice of religion following the annexation of Tibet into the People's Republic of China (PRC) in 1950, thousands of Tibet's monasteries were destroyed along with many of the works of devotional art that they contained and the knowledge of how to make them.

As a direct result of the PRC's ongoing efforts to curtail religious practice, very few Tibetan artists continue today to make traditional art, and an even smaller number now work in a distinctly contemporary vernacular. Although these few artists were born after the initial acts of religious repression, they are trained in the Buddhist heritage—but they are also no longer bound to create art solely in the service of their Buddhist heritage. Yet it is interesting to note that these artists frequently integrate Buddhist symbols and imagery into their compositions, thereby subverting conventional stylistic features and sometimes even conveying a subtext of strong social commentary. Though a fairly common practice for contemporary European and American artists, such boldly individualistic self-expression is only a very recent development for contemporary Tibetan artists.

Since the Rubin Museum of Art (RMA) opened in 2004, it has been dedicated to the display of art from Tibet and the surrounding Himalayan region. The museum's exhibitions have primarily focused on religious themes and sacred art from Tibet, Nepal, Bhutan, India and China. In 2009, the museum broadened its purview to include sacred and secular art from Europe and the United States to compare and contrast artistic approaches to themes such as humans' place in the cosmos and the inevitability of death.

This year, in celebration of the burgeoning field of contemporary Tibetan art, the RMA is presenting an ongoing series of exhibitions that investigate art inspired by the region and by Buddhist philosophy. We begin this summer with "Tradition Transformed: Tibetan Artists Respond," organized by guest curator Rachel Weingeist and RMA assistant curator Rebecca Bloom, with works drawn largely from Shelley and Donald Rubin's collection of contemporary Tibetan art. As the title implies, the art selected for this show reflects the artists' attitudes toward and transformation of Tibetan artistic traditions.

The exploration of Buddhist thought and imagery is certainly not limited to Tibetan artists. Some contemporary Western and Asian artists, who are less constrained by tradition than their Tibetan counterparts, have also been influenced by Buddhist beliefs. The RMA will examine this trend later this year in the exhibition, "Grain of Emptiness."

Thus 2010 begins the museum's full embrace of contemporary art, mirroring the RMA's exhibitions of more traditional art, comparing and contrasting ancient and modern practices, and bringing new insights and interpretive possibilities to each.

—*Martin Brauen,* Chief Curator

Contents

Curatorial Statement
Tradition Transformed: Tibetan Artists Respond

RACHEL WEINGEIST AND REBECCA BLOOM

Tibet has been a place of intercultural exchange for centuries, with influences from the societies of the Indian subcontinent, the Himalayas, China and Mongolia. As a result of these intertwining cultures, Tibet developed an artistic heritage of tremendous complexity and diversity. Generations of artists have passed down their techniques, including the use of stone-ground pigments, to the present, bequeathing to the world a dazzling corpus of murals, sculptures, illustrated manuscripts and thangka scroll paintings.

Since the seventh century CE, Tibetan art has almost exclusively been dedicated to religious subjects. As Michael Sheehy points out in his essay in this catalog, the Tibetan language lacks a word for art that does not imply the rendering of Buddhist deities into a physical, visual form. Artists themselves remained anonymous, their individual achievements subsumed into the religious function of their craft.

The tumultuous events of the 20th century, beginning with China's invasion of Tibet in 1950 and the Tibetan Uprising of 1959 during which the Dalai Lama fled into exile, thrust Tibetan art and culture onto the international stage. As Lhasa's modernization and tensions between Chinese authorities and Tibetan residents have continued into the 21st century, Tibetan artists, while maintaining their centuries-old traditions, are now confronting the dizzying influences of global society. Although most Tibetan artists still create works within the traditional constructs of their predecessors, the nine artists featured in "Tradition Transformed: Tibetan Artists Respond" belong to the new generation that is stretching conventional formulas and artistic norms by extracting sacred symbols from their original contexts in Buddhist art and repurposing them for self-expression.

"Tradition Transformed" began with an invitation to nine contemporary artists, all of whom work with traditional forms in innovative ways, to submit new and recent works. In addition, we selected specific pieces by the same artists from private collections in order to complement the new creations and also to highlight each artist's range.

The artists featured in "Tradition Transformed" are well versed in classical styles and methods, as well as in the strict interpretations prescribed by the Buddhist religion. All of the artists were chosen for this exhibition because they explore contemporary issues—personal, political and cultural—by integrating the centuries-old imagery, techniques, materials and practices found in Tibetan Buddhist art with modern influences and media.

With this exhibition, the Rubin Museum of Art, which is dedicated to the art of the Himalayas, is the first New York museum to exhibit contemporary Tibetan art. "Tradition Transformed" represents the unique position of this groundbreaking generation of Tibetan artists that includes Dedron, Gonkar Gyatso, Losang Gyatso, Kesang Lamdark, Tenzin Norbu, Tenzing Rigdol, Pema Rinzin, Tsherin Sherpa and Penba Wangdu.

Of the nine artists featured in the exhibition, five were born in Tibet, three come from Nepal and one was born in India. Dedron, Tenzin Norbu and Penba Wangdu continue to live in their Himalayan homelands, while the majority emigrated to Europe and the United States at different stages of their lives. All of the artists have benefited from the possibilities of technology, travel and personal artistic freedom, which inform their individual responses to the complex interaction between the traditional and the modern in art and culture. Still they face numerous challenges. Not only must Tibetan artists forge a name for themselves in the competitive international art world, but they also must find their own place within Tibet's rich and formalized artistic legacy—a struggle that has given rise to the works on view in "Tradition Transformed."

All that is ancient is proclaimed to be the tradition of the gods.
All that is modern is thought to be the magic of demons.
Miracles are usually considered to just be bad omens.
This is the tradition of our dharma kingdom Tibet.

This is our tradition as it is today:
The material magic of miracles that benefits everyone,
And the ritual magic of ominous signs that are harmful to all,
Each are sharp sides of a double-edged wisdom sword,
Each are counterparts certain to meet![1]

— GENDUN CHÖPEL (1903–1951)

Transforming a Tradition:
Tibetan Artists on the Dialectic of Sanctity and Modernity

MICHAEL R. SHEEHY

I

Tradition in Modern Tibetan Art

Art is not a word in the Tibetan language. In its modern incarnation, art as an individual's practice of self-expression—i.e. art for art's sake—is found neither in the Tibetan lexicon nor in the Tibetan cultural framework. A discussion of contemporary Tibetan art must then account for the fact that there is no Tibetan equivalent for the English word "art," and consequently no direct correspondence. Despite their rich and complex visual culture, art is an alien idea to most Tibetans.

The closest semblance to a term for art in the Tibetan language is *lha dri ba* (*lha 'bris ba*), which literally means "to draw a deity." The term *lha* itself most simply refers to an animating principle.[2] It is a pre-Buddhist term imbued with indigenous sensibilities about the nature of the tangible cosmos as constructed by elemental energies that gyrate and take shape in specific life forms. Co-opted by Buddhist parlance and equated with the Sanskrit term *deva*, the term *lha* has come to refer generically to living benevolent forces such as gods and local sprites, as opposed to malevolent forces such as demons, or *'dre*. More specifically, *lha* refers also to the complex variety of sublime forms that embody enlightenment. That is, *lha* is a Tibetan cover term for both mundane and trans-mundane beings such as meditational deities (*yi dam*), protectors (*mgon po*) and elemental spirits (*'byung po*). Accordingly, the definition of what it means to be an artist, or *lha dri pa* in the Tibetan creative tradition, is broadly conceived as someone who captures a living animation in vivid form, or someone who symbolically takes a deity captive. **[FIG 1]**

Since the ninth century CE, Tibetan culture has followed the pan-Indian cultural practice of passing down specialized knowledge through an uninterrupted lineal succession, or *parampara* (*rgyud pa*), as in a familial ancestry. This model is typically a residential form of education in which a learned master transmits his or her knowledge of aesthetics, style, technique and symbolism to a capable student. In fact, the Tibetan understanding of what tradition is derives from this structure of learning and this manner of how knowledge is transmitted from one generation to the next.

Within the Tibetan artistic tradition, an accomplished artist, after years of intensive training and apprenticeship, is one who is able to seize and freeze-frame the essence of a particular deity, expressing the precise movement and emotion of that deity in his skilled visual language. Once a deity is drawn or sculpted, in the context of a fresco, statue or painting, each deity is ritually consecrated through a tantric empowerment ceremony so that the deity as mere image is transformed into a receptacle for the actual living presence

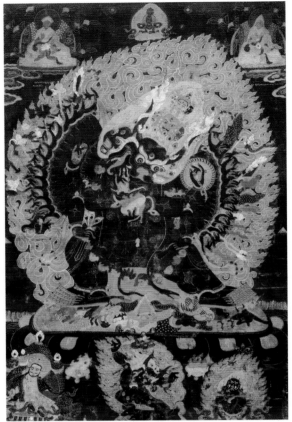

FIG 1

of that particular deity. In this way, the Tibetan artist has traditionally played the role of a mediator of sanctity within the Buddhist cultural matrix.[3]

Though the ideal artist is seen as a creative agent for visually communicating the physique and affect of a particular sublime appearance, Tibetan artists are not typically praised for deviating from formalized visual presentations. In fact, like the Tibetan ritual arts, the Tibetan tradition of visual arts is understood to derive its power and efficacy not from breaking new ground, but rather for its ability to precisely imitate the real yet imaginative world through a range of media. This is to say, an artist is understood to successfully convey his design and style—and thereby to accomplish his or her art—to the extent that the imagery manifests as life-like and inspires a sense of the sublime. At its core, this emulation of a deity is the purpose of the tantric visionary art presented by the Tibetan Buddhist creative tradition.

II

The Artists:
Nine Agents of Transformation

As living Tibetan artists are confronted with modernity, it is understandable that they are consciously or inadvertently working to reconcile inherent tensions at this intersection of their cultural tradition and their practice of art. In doing so, a host of questions naturally arises: What are the ways and means that these artists are adapting their own modern consciousness to Tibetan tradition? Through what technologies, media and styles are Tibetan artists expressing themselves? To what extent are they pushing the boundaries of their culturally defined comfort zones? What reaction, if any, are they getting in return? What social and historical dynamics are at play in the rupture of the Tibetan artistic tradition from its past of relative conservatism and cultural isolation into its present state of celebrity as a commodity on the global market? How are forces of colonialism, consumerism and urbanization being perceived, absorbed and visually represented through this creative enterprise? How is this new Tibetan art being received? Who is receiving it?

As contemporary Tibetan art has only emerged in the past two decades, the answers to such questions remain to be seen. How living Tibetan artists respond will largely define this new movement as either a fleeting trend or a new cultural category. In fact, this is what this current exhibition at the Rubin Museum of Art is about: showcasing how nine contemporary Tibetan artists, as agents of transformation, are breaking from tradition and how each is responding to such questions. In introducing each of these nine Tibetan artists, we would like to highlight some of their works in the context of their training, personal history, sense of cultural and ethnic identity, and artistic contributions.

1
Losang Gyatso

Drawing inspiration for his artwork from millennia of Tibetan history, Losang Gyatso seeks to reimagine Tibetan visual norms. Like many of his generation, Gyatso was born

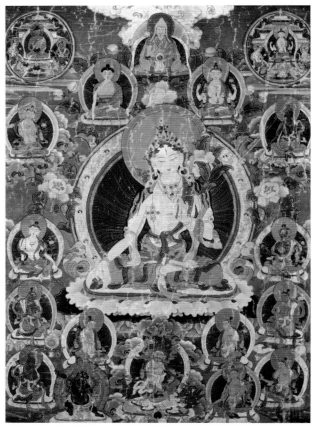

FIG 2

in Tibet but has lived the majority of his life outside the borders of his homeland, growing up in the United Kingdom and moving to the United States in 1974. As a Tibetan looking in on Tibet, his work incorporates multiple facets of the Tibetan aesthetic—from the rock art created by the region's pre-Buddhist Zhang Zhung civilization, to worn-down antiques and artifacts, folk imagery and mythic pictographs, textiles and utility objects, newspaper photos and television screens—presenting this historical imagery in abstract forms.

Gyatso's digital prints conceptually explore a range of visual themes and narratives. His *Green Zone of Amoghasiddhi* (2007) and *Clear Light Tara* (2009), created in the style that he calls "linear painting," exemplify his ability to reinterpret distinctive Tibetan imagery. As if to intentionally blur the normative frames of perception for his Tibetan viewers, he has taken two classic sublime forms from the Tibetan Buddhist imagination and stripped them of their context and convention. Like pixelated images on a computer monitor, each form in these two digital images is exaggerated to the point that its details cannot be visually resolved. In *Green Zone of Amoghasiddhi*, the Tibetan letter *Ah*, which is understood within tantric Buddhism to symbolize the vibrational presence inherent in the power of voice and which is the core syllable of the cosmic Buddha Amoghasiddhi, is visualized as a composition of neon green concentric shapes radiating from dark-red glowing bubbles. Gyatso's *Clear Light Tara*, based on one of the first pieces acquired by the founders of the Rubin Museum of Art, Shelley and Donald Rubin, is a repossession of the form of the female deity White Tara (*sgrol dkar*). **[FIG 2]** By digitally reconfiguring the color schemes of these images, Gyatso has subtracted and refracted the image information to the extent that the images remain recognizable yet are no longer representational.

In these two artworks, traditional images are receding from their symbolic significance; the viewer is left with faint memory traces of their original appearance, embedded and scattered throughout a fragmented re-presentation. In a recent conversation, Gyatso articulated his motivation for creating this piece:

> "I was interested in what a Tibetan thangka looked and felt like to a non-Tibetan who doesn't view it through a complex Tibetan socio-cultural prism, and who brings their own experience of viewing art. This led me to strip away as much culturally-specific information and form as possible, and to reduce the White Tara thangka to as pure a universal manifestation as possible."

He goes on to say, "For Tibetans, a depiction of Tara, or any other deity that they have an affinity with, exudes and pulsates with physical and mental energy. My goal with this project was to create a Tara that would do some of that to a non-Tibetan." Leaving us with an abstraction of the original, Gyatso is at once commenting on the intrinsic linearity of the Tibetan artistic tradition while suggesting that such conceptual and visual distortions are integral to a new Tibetan art.

2
Gonkar Gyatso

Gonkar Gyatso claims that making art comes easily, but that connecting emotionally to his Tibetan cultural tradition is a struggle. In a March 2010 conversation, he described

his life as a boy and young man in Lhasa as being imbued with Chinese tradition, and expressed his frustrations with being disconnected from the cultural observances of previous generations of Tibetans. In fact, it is this great cultural and temporal rift that Gyatso navigates through his art, and which his art has come to embody.

Gyatso has adopted the Buddha as a seminal image in his work. Though he first started working with the sacred figure in 1985, it is his fragmented collages of electric colored stickers and pop-culture magazine cutouts in the shape of Sakyamuni Buddha that Gyatso has made in the last several years that are his trademark. Trained in Chinese brush painting at the Central University for Nationalities in Beijing from 1980 to 1984, Gyatso has also studied classical Tibetan thangka painting in Dharamsala, as well as postmodern art at the Chelsea College of Art & Design in London. In works such as *Panda Politics* (2006), *LA Confidential* (2007), *The Shambala of the Modern Times* (2008) **[FIG 3]** and *The Buddha in Modern Times* (2008), Gyatso is consciously reappropriating the sacred visual forms of the Tibetan tradition. In our conversation, he explained that he believes Buddhism's imagery is outdated, and that his artistic project is connected with modernizing the visual culture of Tibetan Buddhism.

One illustration of this updating of Buddhist imagery is found in his *Wheel of Modern Life* (2010). **[FIG 4]** Besides the image of Sakyamuni, the Wheel of Life (*srid pa'i 'khor lo*) **[FIG 5]** is one of the most central images in the visual traditions of Asian Buddhism. Its form derives from an image that the historical Buddha himself is believed to have sketched on the ground as a teaching device during one of his discourses. Known by its Sanskrit name *bhavacakra*, it literally means "the wheel of becoming," referring to the incessant recycling of unenlightened life. From its center outward, the wheel represents the repetitive tensions at play in the non-Buddha realms of samsara (in contrast to nirvana). The interlinking figures of a cock, a boar and a snake consume each other at the hub of this wheel, symbolizing the forces of aggression, delusion and anger that fuel this cycle of affliction. Graphic illustrations of each of the six realms and their corresponding living beings make up the primary imagery of the wheel, while the outer rim is segmented into 12 distinct sections that depict interconnecting patterns that resemble links of a chain, suggesting its perpetual turning. This entire image in revolution is embraced by Yama, the deity who devours time, thereby taking life.

At the center of Gyatso's rendition in *Wheel of Modern Life* is a Bulgari timepiece. Symmetrically, the clock face has similar divisions with the 12 hours mirroring the 12 links. In classical depictions of the Wheel of Life, there are hungry ghosts whose necks are drawn disproportionately long and as thin as a hair to symbolize their inability to swallow, or images of gods self-absorbed in their hedonistic ways of music and dance. In Gyatso's version, the realms are a random-looking collage of miniature cartoon superhero figurines, magazine cutouts of lipstick tubes, women in bikinis, signs that read "Unlimited LARGE Pizzas" and "BANG," nude body parts, a one-eyed monster crab and palm trees. Dotted all over the wheel are images of dollar bills, dice and lotto balls. Replacing the traditional fruit tree of the gods at the border of the realm of the gods and jealous gods—whose envy is exasperated by the deliciously sweet aroma of unattainable fruit that seeps from its roots—is a money tree. Phrases including "Pay Back," "1 Million Fast Cash," "$3 Off" and "Job" cut from advertisements are interlaced with corporate logos, such as Starbucks', drawing viewers' attention to a contemplation on the commercialization of samsara as

FIG 3

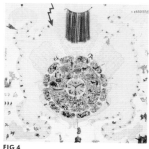

FIG 4

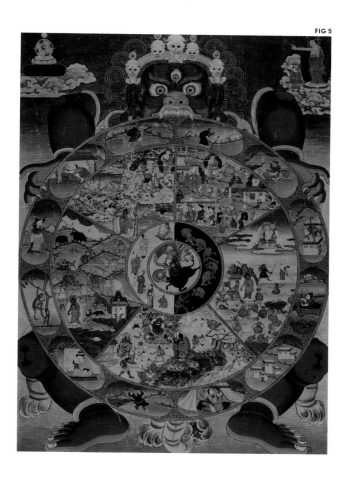

FIG 5

well as the omnipresence of the corporate world. On the outskirts of the wheel, on the backdrop of a muscularly ripped Yama, are insects, pandas, ducks and a menagerie of wandering animals. One gerbil asks, "Do you know anything about falling stocks?" A connoisseur admiring a canvas asks, "Good art or bad art? That is the question."

<div align="center">

3

Kesang Lamdark

</div>

The artwork of Kesang Lamdark presents us with a range of variegated lenses through which to look at Tibet itself as well as the outside world from a Tibetan perspective. Born into the Tibetan diasporic community of Dharamsala, Lamdark was raised in Switzerland and later educated in New York. His experiments with heating plastic, utilizing light fixtures and incorporating industrial materials enable him to visualize imagery that refers to Tibetan rituals and practices in esoteric and often surprising places. His sculpture *Can in Blue Hand* (2007) is comprised of a beer can held by a pair of blue-painted hands; the bottom of the can is pierced by a pin, creating the outline of a nude woman, recalling Tibetan tantric imagery. A similar strategy is employed in works such as *Pussycat*; *Dance of Death: Chitipati*; *Garuda*; *Arhat*; and *Temple Dancer* (all 2007) in which Lamdark works with the symmetry of a mandala. Each of these pieces is a point-by-point pin-prick engraving into the bottom of beer cans that are backlit by natural light so that the outlined forms can be seen through the mouths of the cans.

In *O Mandala Tantric* (2010), a circular, black piece of plexiglass with detailed etchings of tantric imagery is arranged like a zodiac, each constellation floating in a black backdrop. From the sublime form of an anonymous deity in enlightened embrace with his consort (*yab yum*) at its center, the mandala radiates outward, incorporating a round of inverse and reverse heads looking up in opposite directions at the viewer. A second outer layer of skulls is interspersed alongside dancing humanoid figurines with long twisted tails. The outer ether of this concentric space is filled with miniature life-worlds that include celestial Hindu goddesses, tigers, fish, serpents, gymnasts, a yogi with chakras wide open and a range of beings—including elephants and humans—interlocked in contorted sex positions. Looking from its nirvanic center to its outskirts, this is a mandala of rich samsaric imagery. Or it is a true optical display of the tantric view.

<div align="center">

4

Pema Rinzin

</div>

Painting in ways that reach beyond the lines and boundaries of preset formulas, Pema Rinzin's artwork encompasses both classical deity depictions as well as his more recent abstract productions. Trained under the supervision of master Tibetan thangka painters, and the creator of eight major Buddhist paintings for the Shoko-ji Shingon Temple in Japan, Rinzin's style is rooted in tradition. With his semiabstract series of water and knotted cloud images, "Peace and Energy" (2009), displayed as part of the current exhibition, he is challenging the structure and function of Tibetan art by painting pieces that are entirely composed of interweaving traditional line patterns. Inspired by the complexity and richness of this traditional imagery, he insists that it

is fodder for a contemporary Tibetan aesthetic.

In "Peace and Energy," fluid and supple lines create an interlay of overlapping multicolored wave-like patterns, implying that two elements are composed of the same original substance. Articulating a fine precision and an exactness of line movement, as well as a bold natural pigmentation, these compositions offer the viewer insight into the dimensionality of the elements of air and water. As these artworks seem to undulate, billow and surge forth in tangling currents of energetic and colorful inflows and outflows, they radiate with a certain electromagnetic presence, as if to suggest that sublime form is in essence undefined.

5

Tsherin Sherpa

Blending classical technical skills with an ability to imaginatively reform and reconfigure, the painter Tsherin Sherpa transgresses Tibetan aesthetic boundaries. Having undergone training in thangka painting with his father from a young age in Nepal, Sherpa's work is an unusual amalgam of recognizable motifs, such as tantric deities and ritual gestures, which are encapsulated within a broader framework of quintessentially modern compositions. His gouache-painting method uses opaque pigments and acrylic paint in order to give his artworks a peculiar vibrancy and rich texture.

Sherpa's work explores the assault of modernity on classical Tibetan conceptions of art. His *Preservation Project #1* (2009) is a painting of a jar full of multicolored arms stretched outward in all directions with hands cusped in gentle gestures associated with dancers and goddesses, all hovering in the outlines of a blue Buddha head. Evoking questions concerning the nature of preservation—whether it be culture, art, beliefs or thought—the piece captures traditional imagery in a state of homeostasis or self-regulation.

Another work, *Butterfly Effect – The Chaos Theory* (2008), is a complex composition whose central figure is a ferocious oversized semidivine monster engulfed in flames with a vulture looking over his left shoulder. Traced on the surface of the deity monster's blue body are arrows in graphic patterns, pointing to red boxes resembling those in a PowerPoint presentation. While some red boxes are blank, many are inscribed with preset technical Tibetan terms and phrases. On the right side of his bulging belly is the phrase "worldly dharma" (*'jig rten chos*), at the lower edge of his right breast is "passion" (*'dod chags*), at his left wrist is "delusion" (*gti mug*), at each thigh is the phrase "if it does not arise, it is not joyful" (*ma 'byung na mi dga'*), and directed inward from each thigh are straight-arrow meridian lines that point to a red box at the bottom of his lower belly that reads, "if bliss arises, it's joyful" (*bde ba 'byung na dga'*). Reminiscent of Buddhist and meditative body graphs, this piece brings to mind tantric concepts of physiology and the implicit physicality of bliss.

6

Penba Wangdu

Replicating themes derived from Buddhist visual narratives, Penba Wangdu's work brings a playfulness to Tibetan imagery. Wangdu is trained in traditional Tibetan art techniques

and has spent most of his life living in Central Tibet. A professor in the Art Department at Tibet University in Lhasa, he is one of the few living artists who continues to adhere to the traditional use of stone-ground minerals.

Wangdu's set of paintings, *The Five Poisons #5, Ignorance*; *The Five Poisons #4, Jealousy*; and *The Five Poisons #1, Desire* (all 2005), are three of five artworks depicting the five poisons (*dug lnga*), or five distinct toxic emotions, that make up the Buddhist understanding of samsaric living. In each work, the form of the body is laced with clouds, while in *Desire*, a naked male figure is disproportionately twisted and entangled in response to a nude female figure lying beside him in repose, illustrating the distortion caused by his impassioned state. In *Jealousy* and *Ignorance*, male nudes exhibit emotionally charged expressions and postures suggestive of their respective titles.

With *Links of Origination* (2007), Wangdu narrates the classic Buddhist depiction of the 12 links of dependent origination (*rten 'brel yan lag bcu gnyis*) in the traditional style of Tibetan mural painting, playfully reinterpreting it for the modern eye. Extrapolating these 12 links from the outer rim of the Wheel of Life, each of these standard teaching devices is painted over a man's naked body as vignettes that correspond to each of the links, illustrating ordinary conditions for perpetuating paranoia and anguish. There are the usual suspects, including the blind man who symbolizes ignorance (*ma rig pa*), the monkey who symbolizes consciousness (*rnam shes*), the couple having sex who symbolize contact (*reg pa*) and the man with an arrow in his eye who symbolizes sensation (*tshor ba*).[4] Wangdu's version of the typical image of a person with a bottle symbolizing thirst (*sred pa*) is a man drinking from beer cans. Though these episodes are traditionally representational, the imagery of this piece is particularly erotic and facetious. Replicating these motifs while flirting with his own style, this piece takes well-known visual schemes and presents them through a new composition.

<div align="center">

7

Tenzin Norbu

</div>

Inheriting the artistic tradition of his family that dates back over four centuries, Tenzin Norbu was trained as a thangka painter by his father from a young age. His style is illustrative, depicting his momentary visual impressions in landscapes and portraits. Though he paints from Himalayan folkloric imagery and has composed a rendition of the famed Tibetan yogi and poet Milarepa (1052–1135 CE), his compositions reimagine themes and motifs derived from the alpine imagery of his native Dolpo district of Nepal, a remote and largely mountainous cultural region along Tibet's southern border.

Norbu's *Story of the Northern Plain* (2008), *Liberation* (2008) and *Speech and Meditation* (2009) each exemplify the clarity and structure that typify the harmonic effect of his artwork. *Story of the Northern Plain*, a pastoral scene of a highland Himalayan plateau, is the setting for a mythic tale, suggested by the presence of a dragon dangling in a cloud. The story told in the painting is that the Tharok Lake in Dolpo freezes and nomads walk across the ice to the island where they camp for the winter. However, at the end of one winter, a young nomad girl and her dog are left behind, stranded because the ice has melted. During that summer, they watch a dragon fly from the lake and prance in the sky.

Liberation is a portrait of a monk making prayers in the light of butter lamps as human figures rise from smoldering depths, transform into lamps, and multiply into oblivion. Straying further from classical presentation, *Speech and Meditation* depicts the view from inside a cave as the viewer is looking out onto a scene of monks on the grounds of their monastic college and meditation retreat. This suggests a reversal of perspective from the old to the new, as the viewer of Tibetan paintings is typically looking into a cave in paintings where yogis are represented. Though some monks are debating and strolling around in their full garbs as is typical of such a scene, other monks are wrestling, playing soccer, full-mooning the viewer, talking on a cell phone and even riding another monk whose bare behind is exposed.

8

Dedron

The art of Dedron communicates in bolder and more ambiguous ways than that of some of her contemporaries. Trained in the Art Department at Tibet University, Dedron is a member of the China Minority Art Association and of the Gendun Chöpel Artists' Guild, Lhasa's leading collective gallery. Though she is not reconfiguring or replicating traditional Buddhist images, her art challenges trends in the local visual culture. She is one in a handful of Tibetan women artists on the scene, and one of the three artists in "Tradition Transformed" who still lives in Lhasa, the cultural heartland of Tibet.

She speaks of her art as a mode of expressing independence and freedom, but not of political or postcolonial vexations. Her art, she says, is a medium for raising awareness on behalf of women and animals. A fusion of cubist and surrealist styles with subliminal traces of what could be construed as a Mayan idiom, Dedron paints dense visual fields from the realms of humans and animals. Working from memories of her childhood in Tibet, observations of Tibetan social life and reflections on the global eco-crisis, including the rampant slaughter of animals on the Tibetan plateau, she incorporates clouds, mountains, trees, yak, snakes, birds, antelope, nuns and even the Mona Lisa (and other female figures from popular culture) into her portrait and landscape compositions. Her creations allude to her inhabited cultural and ecological space, as her imagery calls into question for most Tibetan viewers the boundaries of deity (*lha*) or demon (*'dre*), the normative social roles of women and a rapidly diminishing respect for the natural world.

With their folksy style, Dedron's paintings are filled with jewel-like tonalities of emerald, indigo and ruby, which complement her use of dark brown and gold pigments extracted from the mineral-rich soil of Tibet. Her contribution to the current exhibition, *Grandparents–Son* (2010), a vertical painting of three pairs of her family members, each representing a generation, provides a visual commentary on the transformation of Tibetan tradition. As in many of her works, the characters of this painting look back at the viewer with bulging oval eyes more typical of contemporary Chinese art than thangka painting. With the painting's vertical composition, she draws viewers' attention across the generations, from her grandparents' to her parents' to her own, depicting the continuity of tradition with the birth of a son. The subtle suggestion of this piece is that more is transformed than just fads and fashion.

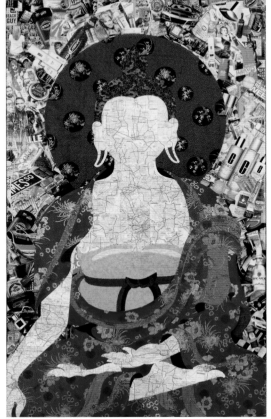

FIG 6

FIG 7

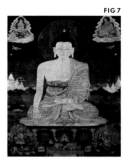

Tenzing Rigdol

Growing up in Nepal, Tenzing Rigdol spent much of his youth at his family's carpet factory. There he developed a discernment for the means of production and the precision of form that has come to define the graphic structure of his artwork. Though he has lived outside of Tibet his entire life, his works challenge traditional Tibetan artistic sensibilities through their composition and arrangement. In his mandala series of 2008, which includes *Obama Mandala*; *Kids' Mandala*; and *Nya-ki-mi-key Mandala*, Rigdol reimagines the traditional mandala (*dkyil 'khor*), an ideal concentric pattern used as a device for ritual and contemplative transformation. He jests at classic tantric presentations, replacing the principle meditational deity at the center with images of Barack Obama, Tom and Jerry, and Mickey Mouse, respectively.

Rigdol's cross-training in graphic design, Tibetan sand painting, butter sculpture, thangka painting, philosophy and poetics mesh to create a synthetic aesthetic. The overlay of acrylic, patchwork, wordplay and pastel watercolor in pieces such as *Fusion: Bud-dha-tara* (2005), *Compression/Blue/Deity* (2005), *Updating Yamantaka* (2010), *Fusion Tantra* (2008) and his reinterpretation of the deity Tara as the Burmese leader Aung San Suu Kyi in his *Updating Tara* (2010), each create a geometrically disjointed collage that captures the gesturing movement of the deities with a psychedelic effect as though they are being reflected from a shattered mirror.

Rigdol's mixed-media piece, *Excuse me Sir, Which Way is to My Home?* (2008), **[FIG 6]** in which he forms the body of the Buddha with a collaged roadmap atlas of the United States over the surface of Sakyamuni, brings to mind the famous story of the Buddha getting lost on his way to Varanasi after his enlightenment under the Bodhi tree in Bodh Gaya, as the Buddha stops to ask a local farmer on the roadside for directions. Buddha's face is marked by the cities of Toledo and Columbus. At his heart chakra is Philadelphia, and in the open palm—the Buddha's earth-touching gesture of awakening—is Cambridge, Massachusetts. The piece also points to ancient Indian and Tibetan understandings of the subtle body as a geographic mandala with direct correlates to specific sacred sites of pilgrimage, or *pitha* (*gnas*). **[FIG 7]** In lieu of the Buddhist visual narrative that depicts the onslaught of demonic forces of egotism, the background of this piece is filled with a collage of magazine images showing consumer paraphernalia, such as cologne and makeup bottles, sports cars, sexy women and iPhones, calling attention to the interplay of materialism and spirituality.

III

New Tibetan Art | New Cultural Space

If the artist's social duty is to comment on how a society is imagining itself at any given moment, then we can safely say that these Tibetan artists are fulfilling their role. In their search for their aesthetic, many of these artists are working intimately and elastically with the imagery of their conscious and subconscious landscape, drawing conceptually and

materially from their imaginal Tibetan cultural horizons. Though there are pervading themes that we can identify throughout the works of these artists—such as the appropriation and recontextualization of iconic Buddhist imagery—these newly emerging art forms are the response of individual Tibetan artists whose collective impact on Tibetan visual culture is only now beginning to be recognized by the global art world.[5]

With practices that both acknowledge and challenge art as a media for communicating and mimicking the sublime, the artists in "Traditions Transformed" thrive on the very concepts that typically defy Tibetan conceptions of art, as well as those tendencies that define the clichés in the dialectic of sanctity and modernity.[6] Though contemporary Tibetan artists are careful not to de-sacralize the imagery of their cultural tradition, they are suggesting more than a departure from the visual norms of their past.

In fact, contemporary Tibetan artists are, ironically, now making contributions to the mediation of the Tibetan cultural dialogue about modernity in ways similar to how artists have historically played the role of a mediator of sanctity in the Tibetan tradition. By invoking and provoking patterns of cultural dissonance as well as by seeking to transfer iconic and imagistic tropes from their cultural framework into their artwork, artists are facilitating a dialogue between the religious and the secular, the old and the new, the ritualized and the commercialized, the meaningful and the inconsequential.

As interlocutors in this emerging dialogue, contemporary Tibetan artists are suggesting a parallel cultural space in which to negotiate their lives and their art. By choosing not to reproduce or replicate the imagistic repertoire of which they are the inheritors, but rather to reconstruct their own technique, media and style in order to express the symbolic and visual language of their cultural milieu, these artists are repurposing the very spaces in which Tibetan art is viewed and interpreted. In doing so, they are both widening the divide with their own formalized tradition while working to loosen the fixity and tightness of its aesthetic.

Through this process of negotiation, each artist extracts the sacredness of traditional forms for the sake of creating modern images. Working to bring familiar imagery out of the insular past and into conversation with the present, artists are stripping art of its ritual and contemplative context and reintroducing Tibetan visual conventions into a foreign setting. As they are doing so, it is interesting to observe whether these artists are making Tibetan imagery more relevant or less meaningful for both Tibetan and non-Tibetan contemporary viewers. Though the decontextualization of traditional symbols is a risk that the contemporary artist takes, many of these artists suggest through their art that this activity alone does not have to define the dialogue. In fact, many artists involved in this movement are seeking to be defined via an entirely distinct cultural category that is disjoined from tradition, yet not divorced from its visual forms.

As is evident in the artworks presented in "Tradition Transformed," each artist has cultivated sophisticated methods for negotiating tensions embedded in this newly emerging alternative cultural space, bringing attention to the social, economic, political and spiritual forces that help define their art. Since that is what artists do—create imaginary spaces—it will be seen in time how the Tibetan artistic tradition as a whole accommodates this new cultural activity. The question is whether the Tibetan culture of the future finds ways to sustain this visual dissonance and refigure its idiomatic imagery while it continues to play its traditional role of communicating the sublime.

Michael R. Sheehy, PhD, is the senior editor of Tibetan literary research at the Tibetan Buddhist Resource Center. He teaches courses on Buddhism, Himalayan visual culture and the Tibetan language at the New School in New York City.

1 Translation by Michael Sheehy. See, Dge 'dun chos 'phel, vol. 2, p. 402. For a bilingual edition and alternative translation, see Lopez (2009), 100–103.

2 It should be noted that the term is a near homophone with the Tibetan syllable la (*bla* as in lama, *bla ma*), which is construed as "spirit" or "life-force" in some contexts. See Wylie and Lopez (1998), 17–21.

3 On the artists' role in mediating the sacred, see Gyatso, 171-173.

4 These representations of the 12 links of dependent origination are somewhat standardized; however it is important to keep in mind the variant visual formulas found in Buddhist art. For a list of select illustrations, see Teiser, 10–11.

5 On the emergence of contemporary Tibetan art in the global context, see Harris (1999); on the use of Buddha imagery in contemporary Tibetan art, see Harris (2006) and Holmes-Tagchungdarpa.

6 On the rise of modernity in conjunction with Buddhism, see Ivy; on modern perceptions of Tibetan art, see Stoddard and Kvaerne.

Blurring Boundaries:
Contemporary Art from Tibet and the Diaspora

ANNA BREMM

Traditional Tibetan art primarily comprises Buddhist sculptures and thangka paintings. Indeed, almost all of the art created in Tibet from the seventh century CE onward is Buddhist, with the exception of a relatively small number of objects created in the service of the so-called Bön religion, and indigenous religion that adopted many Buddhist ideas during their coexistence. During the past few decades, artists in Tibet and Tibetan artists living in exile have developed forms of contemporary art. This new generation of artists expresses ideas freely and works independently from the Buddhist canon. Contemporary Tibetan artists might reference Buddhist images, but when they do, they create meanings different from those of the traditional and sacred functions of Tibetan Buddhist images.

Primarily meditation objects, traditional Buddhist artworks adhere to strict iconometric rules of measurement, although there have been different developments and schools of style during the history of Tibetan Buddhist art. In order to keep the exact proportions of the deities, the figures are copied from stencil books; the proportions of the deity must be preserved exactly in order to be able to transmit the deity's energy through the artwork and facilitate the meditation of the viewer.[1] In the Tibetan language, a painter is called *lha rimo driken* ("one who draws gods"). This term, however, does not suit contemporary artists. A new term, for example *dinge dus rimo driken* ("contemporary artist"), has not yet found its way into formal Tibetan usage. The development of contemporary art in the Tibetan context is not the evolution of traditional art toward modernity, but is instead a phenomenon that has emerged alongside the continuing tradition of Buddhist art.

Whereas Tibetan Buddhist art is already appreciated in Europe and North and South America, contemporary Tibetan art has not been widely exhibited or discussed until this decade, and is still largely unknown to the art-interested public. This essay introduces and contextualizes some of the most compelling contemporary Tibetan artists. The essay's emphasis is the art scene in Lhasa, the capital of the Tibet Autonomous Region in China. The shorter, second part of the essay introduces several Tibetan artists living in exile in Europe and the United States.

Tibetan artists who live abroad have access to different working conditions, educational systems and art markets than those artists living in Tibet, although there is a blurring of boundaries between the two groups. Artists from Lhasa study and exhibit abroad, and artists living in exile travel back to Tibet or their place of upbringing. There is no strict division between the two groups, leading to complex artistic identities that are shaped by a variety of life experiences. Viewed as a whole, the output of Tibetan artists attests to the transformation of Tibetan culture and provides a new perspective on contemporary Tibetan society.

1

Lhasa, Center of the Periphery

The center of contemporary Tibetan art is Lhasa, where most Tibetan artists live as neighbors, colleagues and friends. This close-knit community is on the periphery of the international art market. With 300,000 residents, Lhasa is a small city even by non-Chinese standards. Approximately 300 artists live and work there, including those creating traditional Buddhist art; of those 300 the number of artists working in the contemporary field is around 50.[2]

Most of the artists to be discussed in this essay were born in the 1960s. They belong to the generation that grew up during the Cultural Revolution (1966–76), when a large amount of Buddhist artworks and traditional cultural heritage was destroyed throughout China. The artwork that dominated the society of their childhood and teenage years was Chinese socialist realism and propaganda art. In the early 1980s, when an education in non-Buddhist painting techniques was not yet available in Lhasa, Tibetan artists moved to larger cities such as Beijing for their education. They trained at institutions like the Central University for Nationalities in techniques using oil, ink and tempera painting and learned by copying the European naturalist masters of the 19th century, such as Gustave Courbet. Until they completed their education and returned to Lhasa, most Tibetan painters did not have the opportunity to engage with the Buddhist art of their Tibetan heritage.

Since the opening of the Art Department of Tibet University in 1985, the majority of young Tibetan artists have decided to stay in Lhasa to earn their diplomas rather than go to other Chinese provinces. After a basic education, which is still dominated by learning from copying European masterpieces, art students at Tibet University can choose to specialize in traditional Buddhist thangka painting or train to be a fine-art teacher for school children. Each year, around 30 to 50 students enroll in the bachelor's degree program at the Art Department; one third to one half of the students come from other Chinese provinces to study in Lhasa. The program requires four years of intense education, and out of a normal class only 15 continue their studies until graduation. The master's degree requires three years of study, and the numbers choosing to enroll are much lower, with only three students graduating each year. An MFA program that focuses on artistic training is not yet available, but some younger lecturers, such as Benchung and Gade, encourage their students to develop their own concepts and express their own ideas in "free art" projects; these students experiment with different media, including photography, installations, video and performance art.

After their education, only a handful of graduates decide to work as independent artists. Female students in particular are most likely to stop painting when they start families. In Tibet itself, no contemporary art market exists, and if artists cannot sell their works on the international art market through commercial galleries in Chinese metropolises or abroad, they are dependent on earning a living with other jobs.

In Lhasa, exhibition spaces are few. Besides shows held in foyers of institutions such as Tibet University, only the Tibet Museum is a noteworthy venue, although the exhibitions presented there often have a didactic tone. The exhibition "Painting, Graphics and Photography – 50 Years of Democratic Liberation," for example, which was held in

the summer of 2009, featured a large variety of artworks that were either glorifications of the industrialization of Tibet after its "liberation" in 1950 by the Chinese army or were picturesque depictions of traditional culture. The exhibition did not include many original art pieces, and instead comprised photographs of paintings printed on canvases without regard for their original size.

In order to provide mutual support and to create independent art spaces to show their work in Lhasa, local artists founded two guilds. In 2003, 11 artists joined to form the Gendun Chöpel Artists' Guild, named after the great Tibetan polymath Gendun Chöpel (1903–1951).[3] Today the Gendun Chöpel Artists' Guild has over 20 active members, including all the Lhasa-based artists discussed later in this essay. Dedron and Zhangping are the only female members. Three founding members are ethnic Chinese: Jiangyung, Zhungde and Wang Shimin. Zhungde was born in Tibet, while the other two moved to Lhasa after their education. The purpose of the Gendun Chöpel Artist's Guild is to promote the creation and development of contemporary art in Tibet, regardless of an artist's origin or religious background—whether they are Buddhist, Bön, Muslim or non-religious.

The Guild's art space, known as the GC Art Yard, is an important component of the Lhasa art scene. From 2003 until late 2008, the gallery space was located at the Barkhor, the circuit road around the Jokhang temple, in the heart of the old town. Additionally, during its early years, the Guild held several exhibitions at the Yak Hotel. In May 2009, the gallery relocated to a house on the island at Kyichu River. With two floors, an atrium and six additional rooms with white walls, the space provides the Guild's members with the opportunity to display their own works and to invite other artists and students to exhibit there as well. The Guild organizes between two and five group or solo shows a year, and its space is also used for lectures and art events. Their library, built on donations from artists and foreigners, is one of the few places in town where art books and journals can be found. The other artists' guild, the Shunnu Dame—a name that is hard to translate into English but means roughly "unbeatable youth"—was founded by six former students of Tibet University. Unlike the Gendun Chöpel Guild, Shunnu Dame does not yet own an exhibition space, making it difficult for audiences to see their work outside of studio visits. Nevertheless, the members support and encourage each other in their development as contemporary fine artists.

Despite the presence of the GC Art Yard, contemporary art is still almost invisible in Lhasa. Instead, tourist-oriented art shops in service of an ever-growing tourist industry dominate the city center. Since the implementation in 2006 of the railway that connects Lhasa to major Chinese cities, the number of tourists in Tibet has increased 86 percent to more than 1.5 million visitors per year, a number projected by official Chinese reports to grow to an estimated 10 million by 2020. More than approximately 80 percent of the tourists come from other Chinese provinces, lured by tourist agencies that advertise Tibet as a counter-balance to unhealthy city life. From the gallery at the Lhasa airport to monastery gift shops, tourists can choose from a large variety of photo-realistic canvases, showing Tibet's sunny side: smiling nomads in traditional garb, praying monks with rosaries and beautiful landscapes of the high plateaus.[4] These tourist souvenirs propagate an idyllic myth about Tibetan life. Tibetan traditional culture becomes a field of projection for desires of spirituality, adventure and exoticism.[5] In order to meet the tourists' demand

FIG 8

FIG 9

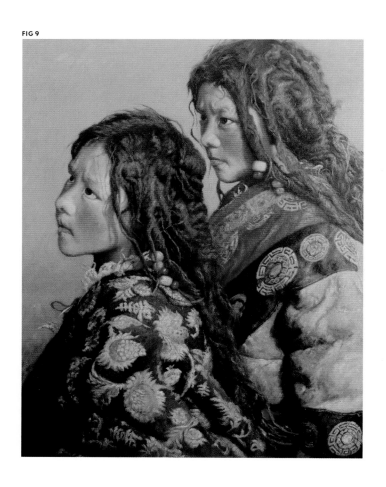

these canvases are not only produced by local painters to earn a living, but also imported in masses from other Chinese provinces. Though these souvenir paintings hardly deserve to be called art, they need to be mentioned here as they dominate the streets of Lhasa and are the primary non-Buddhist images of art in Tibetan society.

2
Tibet's True Colors

Despite the unfavorable circumstances for art training in Tibet, some artists in Lhasa have excellent skills. For example, Tsewang Tashi (b. 1963) and Tserang Dhundrup (b. 1964) are both technically accomplished painters whose unique approaches represent opposite ends of a rich spectrum in contemporary portraiture. In *Beer Seller No. 1* (2009), **[FIG 8]** Tsewang Tashi paints a confident young woman who gazes directly at the viewer. Fashionably dressed with stylish earrings and a sports jacket, she has a modern, short haircut and her skin is tinted neon-green. Her accessories identify her as a modern, fashion-conscious woman, and neither her clothing nor her skin color marks her as an ethnic Tibetan. Nor is there a backdrop to provide any narrative context. Only the title indicates her possible story: that she works as a promotion girl for a beer company, a growing business in Lhasa's nightclubs.

Since 2000, Tsewang Tashi has focused on portraying a new generation of Tibetans growing up with the internet, cell phones and computer games. Born in Lhasa, he graduated from the Central University for Nationalities in Beijing in 1984 and received an MFA at the Oslo National Academy of Arts in Norway in 2001. Currently he is writing his PhD on the contemporary art development in Tibet at the Norwegian University of Science and Technology in Trondheim and spends half the year in Norway. At the beginning of the 1990s, Tashi stopped using Tibetan ethnic symbols in his paintings altogether. Between 1993 and 2000, he painted a series of landscapes of the Tibetan plateau untouched by civilization.[6] His current portraits of anonymous Tibetans are painted on larger-than-life-scale canvases, which until the late 1970s were reserved for portraits of Mao Zedong. In Tashi's art, ordinary people step out of the masses and are freed from the politicized facial expression used in Chinese socialist-realist depictions of Tibetans.

By using the techniques of realism, Tserang Dhundrup's painting *The Sisters* (2005) **[FIG 9]** captures another side of contemporary Tibet, showing two young girls in half-profile with suntanned faces and rosy cheeks. They are dressed in traditional fur coats richly ornamented with Chinese brocades. Their long hair is partly braided but still matted and unkempt. They hold their heads slightly turned upward with a scrutinizing gaze, almost a scowl. Based on their clothing and hairstyle, it appears that the girls belong to a Tibetan nomad family.

Tserang Dhundrup was born in Labrang, Amdo, and studied at the Northwest University for Nationalities in Lanzhou and the Central Academy of Drama in Beijing before staying as an artist-in-residence at the Banff Centre in Canada and at the Snug Harbor Cultural Center in New York in 2001. Today he works as a painter and stage designer in Lhasa. His oeuvre includes realistic depictions of historic monasteries and famous buildings such as the Potala Palace, as well as portraits of Tibetans of all ages dressed in traditional attire. His subject matter may appear similar to that of tourist art,

but his highly perfected technique of representational oil painting distinguishes him from the mass-market copyists: Dhundrup often works for three months or more on a single painting. And though he has tried abstract painting, he feels more comfortable in a naturalist style.[7] According to Dhundrup, every new trend in art originates from a past tradition. Therefore, no entirely "new" art exists—everything is interconnected and results one from another in an ongoing cycle of influences.

Though the styles of Tsewang Tashi and Tserang Dhundrup differ noticeably, the artists started from a similar background, first studying in China and later in the West; and both work to portray modern Tibetan youth. Tsewang Tashi's neon woman is not a futuristic vision, nor are Tserang Dhundrup's nomad girls a nostalgic look at the past. They represent two sides of contemporary Tibet.

Other contemporary artists create powerful images by joining tradition with modernity rather than choosing between them. One such example is "Hi the Body" (2009) [FIG 10], a suite of staged photographs by Zhangping (b. 1977), who was born in Lingling, Hunan province. To create the series, the artist positioned two painted plastic female mannequins on a highway to Lhasa so that a group of prostrating pilgrims, moving toward the holy city of Lhasa, would bump into them. Traveling on a new asphalt road, the pilgrims still observe the traditional religious way of journeying; sunk in prayer, they measure their route with their bodies, bowing down toward the sanctum, the goal of their pilgrimage. The photographs show that the mannequins, richly ornamented with Buddhist imagery and decorative elements of thangka paintings, draw their attention. In one picture, one of the pilgrims "gets in touch" with contemporary art by placing his hand on the mannequin.

Zhangping is one of the few female contemporary artists living in Lhasa. In her work, she refers not only to changes in society, but also to the role of women.[8] She decorates the naked female mannequins with Buddhist images, confronting "the impure" with "the pure"—a deliberate affront to the Tibetan Buddhist society that has traditionally regarded the female body as impure. She indicates that in contemporary society women treat their own body as a product in order to be loved and accepted. The mannequins become significant placeholders in religious and social contexts, especially when they unexpectedly interact with traditional Buddhist pilgrims.

Zhangping came from Beijing to live in Lhasa with her husband, Jiangyung, in 2001. Jiangyung (b. 1972) is a founding member of the Gendun Chöpel Artists' Guild, and both are active participants of Lhasa's art scene. Jiangyung addresses themes similar to those in his wife's work in his painted portraits of Tibetan Barbie dolls, which serve as ironic commentaries on the commercialization of indigenous culture. In a 2005 series he portrayed Barbies dressed in *chuba* (the Tibetan garb) and wearing *gau* (amulets filled with blessed objects) and the traditional headdresses of the historical Tibetan regions Ü-Tsang, Amdo and Kham.

Buddhism has undeniably shaped traditional Tibetan culture; in fact, the Tibetan alphabet was developed in the mid-seventh century CE in order to translate what became the *Kanjur* and *Tanjur*, the words of the Buddha and their commentaries by Indian scholars, respectively. The Lhasa-born artist Gade (b. 1971) adapted this symbol of traditional culture and started a series called "New Scripture" in 2005, which now numbers over 50 pages. The sheets of handmade paper have the dimensions of *pecha*, the wide-landscape

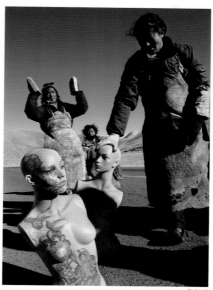

FIG 10

FIG 11

FIG 12

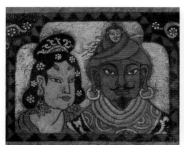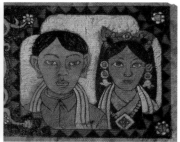

FIG 13

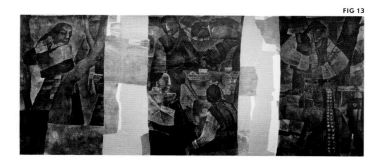

format of Buddhist scripts that traditionally were stored loosely between two wooden book covers. Though Gade's "New Scripture" pieces adopt a traditional format (he also uses mineral pigments from Central Tibet), there is no Buddhist philosophy found on Gade's parchments. Instead, there is a mixture of ancient forms and modern imagery. One page shows Buddha replacing Jesus at the table of the Last Supper. His disciples include Mickey Mouse, the mystic bird Garuda, a wild warrior from Kham, the Hollywood alien ET and a Chinese cadre. Together the characters represent aspects of Tibetan, Chinese and Western cultures. Similarly, *Seer* (2006) **[FIG 11]** shows the Buddha wearing the uniform of the People's Liberation Army and flanked by a Chinese emperor and Elvis. The Buddha and Mao merge into one hybrid figure just as the words Gade has written on the paper are a mixture of Chinese characters and the Tibetan alphabet. It is impossible to separate them, and in their fusion, they are indecipherable.

Another page of the "New Scripture" is the portrayal of the phenomenon of mixed marriages in Tibet. In the center of *Group Photo* (2006) **[FIG 12]** is the Tibetan Dharma-king Songtsen Gampo with his Chinese wife Wencheng. Their often-referenced marriage in the seventh century CE marks an important point in Sino-Tibetan history. The famous mixed-marriage couple is flanked on one side by a Tibetan Khampa and his Western wife, and on the other side by a Tibetan woman with her Chinese husband. The historical couple surely resonates with today's youths; a new generation of Tibetans in Lhasa, including Gade himself as well as those in exile, is growing up with dual ethnic identities.

For Gade, merely creating beautiful objects would not be enough as an artist. He feels his responsibility is to make his audience aware of Tibet's rapidly changing culture.[9] But his emphasis on transformation should not be understood as a broad condemnation. On the contrary, Gade supports the spread of globalization to Lhasa and argues against any spiritual idealization of Tibet that is often perpetrated by Chinese and Western media. With his "New Scripture" series he rewrites Tibetan history and compels viewers to update any nostalgic views they may hold of Tibet.

3
Turning Outside In and Insight Out

During the last few years, a growing number of Lhasa artists have distanced themselves from direct references to traditional Tibetan culture. Rather than playing with forms of visual tradition and modernity, these artists are integrating states of mind and human emotions into their work. In a relatively short period, several artists' oeuvres have undergone dramatic shifts in style as they search for suitable modes of expression, often leading the same artist to create a set of wildly disparate paintings.

One example of rapid artistic transformation is found in the work of Lhasa-born painter Benchung (Benpa Chungda, b. 1971), who studied at the Art Department of Tibet University and later at Tianjin Academy of Fine Arts. Soon after his graduation in 1992, he started to teach at Tibet University. An example of Benchung's early style is *Picnic No. 2* (2001), **[FIG 13]** a large landscape-format painting divided into three vertical panels separated by two unpainted columns that show the structure of the canvas, which has been sewn together with many smaller patches and resembles the thick yak-wool

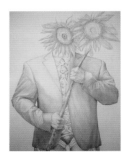

FIG 14

FIG 15

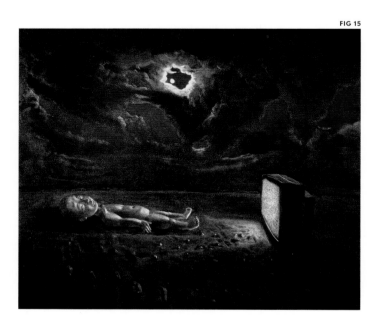

curtains that hang over Buddhist temple entrances. In the central panel of the painting, four people dressed in *chubas* gather around a low wooden table drinking tea. The scene on the right shows a woman at a butter churn. The dark lighting recalls the interior of Buddhist temples and traditional households with butter lamps and grime-covered walls. Indeed, Benchung was inspired by the Gönkhang, the black-painted chapels dedicated to protector deities and the dark curtains of Buddhist temples.[10] Radiating from this quietly detailed painting is an atmosphere of calmness. Looking at *Picnic No. 2* and other paintings of this period in Benchung's career is like diving into traditional Tibetan culture—the harshness of everyday life on the one hand, and its celebratory nature on the other—with no evident signs of modernity.

Like Tsewang Tashi, Benchung received further education at the Oslo National Academy of Arts from 2006 to 2007. During his studies in Norway, he experimented with many media, including video, photography and drawings with butter, which enriched his painting. Seven years after *Picnic No. 2*, Benchung's style and focus had changed completely. For example, in *Sunflower 089* (2008), **[FIG 14]** a figure, shown from the waist up in a blue jacket and tie, holds a sunflower in front of his chest. His clenched fists hold the stem as if it were a rifle. His legs are bare, his upper body is bound and his head is replaced by another sunflower. The bright colors make the painting look cheerful, but *Sunflower 089* is tense and frightening. Using only a few choice elements, Benchung evokes disruption and unease. Compared to his early works, his palette is much lighter and his scenes are less folksy. His realism has given way to a complex surrealism. The subjects of his paintings now lack any Tibetan-specific ethnic identifiers.

A similar shift from folksy scenes to tense, surreal situations is found in the paintings of Tsering Nyandak (b. 1974). In his early works Nyandak referred to traditional Tibetan culture by dressing his characters in Tibetan garb or showing traditional gestures, such as the way of respectful greeting by slightly sticking out one's tongue. In recent years, however, Nyandak's canvases have evoked darker moods, as his palette is now dominated by cold blues, violets and grays. In some of his paintings, his subjects are dressed in rugs, but more often they are naked, not allowing any clear identification through specific clothing. The heads of his figures are often shaved and, in their naked vulnerability, it is hard to say whether they represent grown-ups or babies, or whether they stand for individual stories or are representative of their generation. Unlike most artists in Tibet, Nyandak does not copy from photographs, but works entirely from his imagination. *TV* (2008) **[FIG 15]** shows a human body lying on a vast, rocky landscape. The figure is motionless, his eyes closed as if sleeping. It is late at night and the moon is peeking through the cloudy sky. The light that shines on the body comes not from the moon but from the blank screen of a television. The empty landscape recalls the Tibetan plateau as well as the artificial landscapes used as backdrops for video games. The painting could be a depiction of the disillusionment of young people, fleeing into parallel worlds, such as computer games and movies, in order to avoid life.

Another contemporary Tibetan artist who deals with basic human emotions in his work is Lhasa-born Nortse (Norbu Tsering, b. 1963). In an ongoing series of self-portraits, begun in 2007, Nortse masquerades in various guises. In *Guarding Against Catching a Cold* (2007), **[FIG 16]** he wears a red jacket and a belt from which hangs a *mi-long*, a traditional amulet used for protection against demons and evil spirits. In the self-portrait he also

wears a mask decorated with a little dog over his mouth. At first glance, the man's apparel appears clownish, but paired with his unblinking gaze and folded arms, the humor quickly evaporates and becomes an uncomfortable seriousness.

Nortse is never afraid to change his style or to abandon the well-trodden path and try something completely new. He has experimented with a variety of media, including plastic tubes, tobacco leaves, metal and paper clothing. From 1980 to 1991, Nortse studied oil and ink painting at the Central Academy of Fine Arts in Beijing, the Art Academies in Guangzhou and Tianjin, and Tibet University. Nortse has since worked in many different professions, from designing carpets to running a tourist art gallery, an advertising agency for painted billboards, a small factory for handmade paper, and operating a photography studio that specialized in weddings. He also worked for the Tibetan television station XZTV as a set designer.[11] As a result, his works often feature interior spaces and rely on the use of props.

For example, Nortse's painting *5/12* (2008) **[FIG 17]**, shows the interior of an empty office with an abandoned chair. An electric light bulb, hanging above the table, is broken and bandaged with white plaster. A white tablecloth covers the desk and is stained with red wine from an overturned wine glass. A butter lamp is lit, and a pile of newspapers on the desk and the calendar on the wall both indicate that the date is May 12, the date in 2008 when an earthquake shook large parts of Sichuan province, including the eastern Tibet region of Kham. During the devastating earthquake, when buildings collapsed, burying people alive, an estimated 80,000 people died; many families lost their only child.

As reflected in Nortse's painting about the Sichuan Earthquake, most artists in Lhasa share the opinion that their artwork should be connected to life and that life should find visual expression, often in a naturalist and realistic style, in their artwork. There is less consensus however about how much human feeling and states of mind should, or can, be expressed in art. Another matter of fierce debate among Lhasa artists is how much "ethnic" reference is required to qualify as a piece of Tibetan contemporary art—or indeed, if it is necessary at all to keep a visual link to traditional Tibetan culture.[12] All of the artists discussed above have exhibited internationally and traveled to Chinese art metropolises such as Beijing and Shanghai, and many of them, except for Zhangping and Jiangyung, have traveled to Europe or the Americas. Through their travels, and their virtual journeys via the internet, the artists have become familiar with the international contemporary art world. But instead of copying trends from the global art world, they develop their own ideas and ways of expression.

4
The Other Side of the Himalayas: Tibetan Artists in the Diaspora

Around 200,000 Tibetans live in India, Bhutan and Nepal, of whom only around a dozen are contemporary artists. The Tibetan exile communities in Asia place great importance on the preservation of and education in traditional culture. For that reason, families from Tibet often send their children to school in Asian exile. Most contemporary Tibetan artists in India received a classical education in thangka painting before going on to train themselves in more contemporary styles, as there are few opportunities to study oil painting in the Tibetan exile community in India. One exception are the art classes

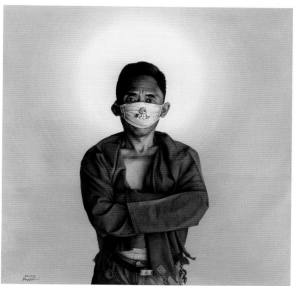

FIG 16

FIG 17

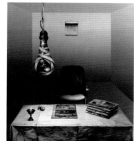

at the Tibetan Children's Village schools, which were created as alternative training for those who drop out of school and teach students to paint photo-realistic copies of postcard images of Tibet.

Like their counterparts in Lhasa, the majority of artists in Asian exile are painters. Several of them, such as Samchung (b. 1975), came to live in exile after completing their education at a Chinese art academy. Their topics are primarily romanticized references to traditional Tibetan culture. The Tibet Museum and the Amnye Machen Institute, both in Dharamsala, the base of the Tibetan government in exile, have featured small exhibitions of such local artists.

The artists who want to start professional careers in contemporary art emigrate to the United States and Europe, where Tibetan populations remain small. In the US, it is estimated to be around 9,000; in Europe, the majority of Tibetans live in Switzerland, which claims around 3,500 Tibetan residents. Whereas the majority of artists in Tibet and in Asian exile are painters, Tibetan artists in Europe and the US employ a greater variety of media.

Of the Tibetan artists working in international contemporary styles, Gonkar Gyatso (b. 1961) is probably the most well known since his inclusion at the 2009 Venice Biennale. His complex collages combine stickers and visual elements of consumer culture with references to thangka painting and the politics of Tibet.[13] Gyatso studied with Tsewang Tashi in Beijing and, after his return to Tibet, he taught at Tibet University where Benchung was one of his students. Together with Nortse, Gyatso organized an exhibition at the Sweet Tea House Association in the 1980s. After studying traditional thangka painting in Dharamsala in the 1990s, Gyatso moved to London to study. There, after attending graduate school, he opened the Sweet Tea House Gallery in 2003, making it the first gallery in Europe to specialize in Tibetan contemporary art.

His cross-cultural experiences and the complex influences and development of recent Tibetan art are summed up in his series of four photographs entitled "My Identity" (2003), each image showing the artist at work on a canvas in an identical posture. However, in each of the four images, he is dressed as a different kind of Tibetan artist: a traditional thangka painter, a Chinese propaganda artist, an exiled painter in Dharamsala painting the Potala Palace and an abstract painter living abroad.

Born in Tibet, a longtime resident of Switzerland and now living in New York, Sonam Dolma (b. 1953) is the only Tibetan-born female artist living and working outside of Asia who has exhibited her work. Her installation *Red Carpet* (2010) **[FIG 18]** features a large collection of traditional clay moldings of miniature Buddhist images (*tsa tsas*) in the shape of a *stupa*, an early Indian grave monument that is a familiar symbol of the Buddha and his teachings. The making of *tsa tsas* is a Tibetan Buddhist practice to accumulate merit, and they can be found everywhere in Tibet, often piled up at a *khora*, a circuit route around a sanctum. In Dolma's installation, they stand on a wooden disc, lined up in tight narrow rows and arranged in a circular field. The perfect geometrical form is intersected by a long red stripe of red carpet. With the intrusion of the red stripe, the small rows of *tsa tsas* are transformed into an anonymous mass that seems to be watching an official or military parade. The power of Dolma's work comes from placing familiar Buddhist objects in a new context, thereby creating new meanings, like ready-mades.

Another of Dolma's installations shows nine of the stupa-shaped *tsa tsas* protected

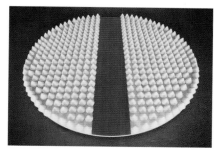

FIG 18

FIG 19

by piles of folded monks' robes. Traditionally monks should not have more possessions than their clothing. The title *My Father's Death* (2010) **[FIG 19]** offers a biographical link. Sonam Dolma was born in Tibet and came to India when she was six years old. After the exhausting escape from Tibet, her father—like many in the first generation of refugees—worked in road construction. Shortly before he died, he asked his wife to conceal their relationship because the family had no money to pay for his cremation. Some Tibetans place ashes of the deceased in *tsa tsas* and leave them at holy places. A *tsa tsa* mold was among the few possessions that Dolma's family brought on their escape to India and she used it for the matrix of her *tsa tsas*. All together she used 49 monk robes for her installation, as in Tibetan Buddhism special prayers have to be read for 49 days after death. With the installation *My Father's Death*, Dolma creates her own space of memory as well as a memorial to others who have died in exile. Her Tibetan roots lie in vivid memories of her childhood and in everyday customs and rituals that undergo renewed considerations through her art.

Tashi Norbu (b. 1974), who combines Buddhist images and elements of thangkas with a free style akin to modern abstraction, studied traditional thangka painting and worked as a thangka painter in Dharamsala, India, in the 1990s before moving in 2000 to Belgium, where he studied visual arts at the St. Lucas Institute of Visual Arts in Ghent. In his works he joins accurate representations of mandalas and Buddhist deities with collaged elements and an expressive handwriting. In his painting *Touching the Earth* (2008), **[FIG 20]** the Sakyamuni Buddha sits in a meditative posture beneath a Kalachakra mandala with his back to the viewer. The vast space around him is filled with blue, white, red and yellow colors, which have been applied to the canvas in an abstract-expressionist manner. Norbu's paintings include elements of Tibetan Buddhist culture, such as scripts, mantras and prayer flags. Presently based in Amsterdam, where he runs the Tibetan Art Movement Foundation, Norbu feels a deep connection and responsibility toward Buddhist ideals and hopes to transfer the beauty of Tibetan traditional culture into the modern world. Aside from his work as an artist, Norbu organizes exhibitions representing exiled Tibetan artists and Western artists who relate to Tibetan culture.[14]

The work created by Tibetan artists in exile reflects their explorations of cultural identity and their experience of living far from their homeland. Puntsok Tsering (b. 1976), for example, has lived in Germany since 1998. He mixes traditional Tibetan calligraphy with modern elements of collage, combining them with his poems that offer troubling reflections on Tibet. Through his words, the audience is confronted with the inner conflict of living in two cultures.

This topic is addressed in numerous ways by Kesang Lamdark (b. 1963), whose *Tibet Pavilion* (2005) consists of two containers arranged like contractor's sheds. The first is papered with photographs of Lamdark's biological Tibetan family, and inside the second are the faces of the Swiss family that adopted him. The viewer can move between the two rooms, symbolic of Lamdark's two homes. In 2005 Lamdark proposed the project to the Venice Biennale to represent Tibet with its own pavilion. According to Lamdark, the jury rejected the work so as not to provoke the festival's Chinese sponsors, and the piece exists only as a proposal.[15]

Interesting examinations of Tibetan cultural identity in exile have been made by artists working with film. Yonten Gompamitsang (b. 1978), who grew up in Tibet and

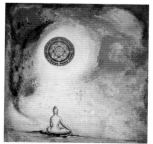

FIG 20

FIG 21

FIG 22

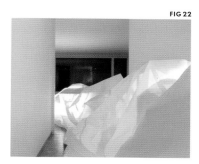

in Switzerland, created a documentary, *Ein Genosse im Bundeshaus* ("A Comrade in the House of Parliament") (2008) about the first visit of Chinese president Jiang Zemin to Switzerland in 1999. Peacefully demonstrating Tibet activists angered Jiang, which led to his fiercely reproaching members of the Swiss parliament. Through interviews with politicians and Tibet activists, the film documents and recalls the importance of this event in the history of exiled Tibetans. Another noteworthy film is by Swiss-born Lobsang Tashi Sotrug (b. 1984), whose *Vaterland & Tröim* ("Homeland & Dream") (2008) pieces together fragments of childhood memories. The film expresses a longing for a country the artist himself has never known and the search for belonging that often characterizes exiles' identity.

Artworks by Tibetan artists in exile do not all refer to traditional Tibetan culture or contemporary Tibetan issues. In fact, the oeuvres of many of the artists discussed above contain a variety of work that often does not refer to Tibetan culture directly, as in Sonam Dolma's abstract paintings, Kesang Lamdark's pierced beer cans or other films by the young filmmakers from Switzerland. Indeed it is a growing tendency, especially from the younger generation of artists, to focus on more universal forms of artistic expression.

The development of a more universal style is evident in the work of two younger artists. Palden Weinreb (b. 1982), a New York-based artist, creates abstract works that do not allow for any narrative readings, ethnic or otherwise. With fragile lines and circles created in graphite on paper and covered in tactile layers of wax encaustic, he contemplates basic geometrical forms **[FIG 21]**. His delicate drawings contain the signature of the artist but reveal little about his ethnic background.

Also working with formalist concepts is Switzerland-based Tashi Brauen (b. 1980), who is interested in physical space. His installation *Interieur* (2008) **[FIG 22]** is a huge white industrial awning that fills large parts of the exhibition space and makes it difficult for the audience to navigate the room. Brauen places furniture and light sources under the awning, the forms of the furniture tracing shadows onto the awning's fabric skin. Together with sound recordings made while moving the objects in the space, his work interferes with the audiences' habitual perceptions of space. Along with the installation itself, Brauen exhibits photographs of his installations on the walls of the space, allowing the three-dimensional installations to interact with its two-dimensional representation. Brauen's pieces pull the viewer into the present moment; they need to be experienced in situ. Though he feels a deep connection to his Tibetan roots, Brauen does not express it visually in his art.[16] In this way, he represents a new generation of Tibetan artists.

As the work of artists in exile reveals, many Tibetan artists today work independently from a Buddhist context. The boundaries between traditional and contemporary styles are blurred, as some artists—such as Gade, Tashi Norbu and Sonam Dolma—mix modern elements and traditional techniques, while others—among them Benchung, Tsewang Tashi and Tsering Nyandak—avoid direct visual references to traditional Tibetan culture in their works. As there is no prescribed form for how Tibetan contemporary art should appear, each artistic articulation invents a new form. Altogether, the artworks introduced in this essay present Tibetan culture from a new perspective, adding a new dimension to what Tibetan art looks like today. The examination of contemporary Tibetan art offers the possibility to revise romanticized images of Tibet and experience contemporary Tibetan culture—beyond the exotic—with all its contradictions.

Anna Bremm, MA, is an art historian and cultural scientist; she wrote her thesis on contemporary Tibetan art at Humboldt University, Berlin (2008). In the summer of 2009, she resided in Lhasa on a curator's research grant from the Goethe-Institut.

1 On traditional Buddhist art, see Dagyab Rinpoche, J. Gyatso, Gompojab, and Jackson.

2 This estimate of 300 artists has been made by Tsewang Tashi, lecturer at the Art Department of Tibet University, and myself.

3 Gendun Chöpel was a Buddhist monk, poet, historian, scientist and translator. He was also trained as a thangka painter and sketched in a modern style. He sometimes is referred to as the first modern artist from Tibet. Chöpel's critical view on the old strictures of Tibetan society provided him with more enemies than friends, so a large part of his oeuvre had already disappeared before the Cultural Revolution. Today, just a few of his sketches have survived. For more information on Chöpel, see Lopez (2006).

4 The motifs are often inspired by paintings of Chinese artists such as Chen Danqing and Sun Jingbo who came to Tibet to find inspiration from the indigenous culture in the early 1980s. Chen Danqing's oil paintings of the "Tibet Series" (1980–84) portray rural Tibetans and religious practice, and they still serve as examples of Tourist art. See Harris for more information.

5 On common myths of Tibet, see Brauen, Dodin and Räther, and Lopez (1998).

6 For insight on the development of his art, see Tashi.

7 From an interview with the artist in May 2007.

8 The artist stressed this during a studio visit in 2009 as well as in an unpublished statement on her photo series.

9 Information based on interviews and conversations held in May 2007 and summer 2009 in Lhasa.

10 Information based on interviews conducted between 2006 and 2009 in Europe and Lhasa, an unpublished 2009 statement by the artist on his paintings, as well as his unpublished 2007 master's thesis.

11 Information provided by the artist during studio visits in 2007 and 2009.

12 This conclusion comes from numerous conversations held with artists from Lhasa, as well as from a conversation at GC Art Yard in June 2009, when around 50 to 60 artists and art students from Lhasa were present.

13 On the biography of the artist, see G. Gyatso.

14 Based on correspondence with the artist in February 2010.

15 Information based on an interview held with the artist in his studio in Zürich in 2007.

16 Information based on correspondence with the artist in 2010.

"Nowadays, the ancient Buddhist mantra,
Om Mani Padme Hum, seems to be
changing into Om Money Money Hum."

—H.H the Dalai Lama[1]

Enlightenment Might Not Be Possible in This Lifetime: Strive for Your Own Liberation with Laughter and Diligence

HG MASTERS

There is no McDonald's in Lhasa yet. But when it does open—two years from now, or ten—the collective outrage will not matter, as it didn't when McDonald's opened locations in Mecca in 1994, near Venice's Piazza San Marco in 1997 and in the center of Cusco, Peru, the former capital of the Incan empire, in 2008. The presence of multinational food retailers such as McDonald's or Starbucks in historically revered or even sacred spaces is now familiar to local residents and travelers alike.[2] The resultant collision of traditional architecture, culture and commerce with the aesthetics, iconography and branding of an arch-modern corporation is one of the defining experiences of 21st-century life.

This cultural discord is experienced in another way by millions of rural inhabitants who, in countries such as India and China, have moved to regional metropolises or abroad and confronted modernity in its prime manifestation, the city. That modernity, embodied as often as not in global consumerism and technology instead of in the individual rights of liberal democracy, such as voting or freedom of expression, has spread with differing rates of progress—and with local characteristics—is reflected in the contemporary art made by artists around the world. The juxtaposition of the traditional and the modern is, by 2010, a contemporary art truism, and it has found an analogous visual language in the self-conscious, eclectic recycling of aesthetic styles identified as postmodernism.

Despite the familiarity, even banality, of this condition, it is jarring to see logos for the Eurostar train, Starbucks, Barclays Premiership, the Broadway musical *Wicked* and Costa Coffee carefully arrayed and radiating from the Buddha's head in Lhasa-born artist Gonkar Gyatso's four-panel, mixed-media collage, *The Shambala of the Modern Times* (2008). Together with colored stickers of ice-cream cones, princesses in pink dresses, gold stars and panda bears and snippets of headlines—"to boycott Beijing," "Tibet leads Charles," "our Olympic showpiece / ended in / violence and farce"—and banal advertisement pitches—"when you recycle your old Clubcard" and "NO UPFRONT FEES"—these signs of contemporary life comprise the Buddha's aura, demonstrating the boundless compassion of Sakyamuni, who confers holiness on all things materialistic, vulgar and plebeian. It is a mess of banal commercial signs and overtly manipulative slogans from throwaway packages and unsolicited junk mail mixed with anti-China rhetoric, like the trash left behind in Piccadilly Circus in London by some raucous Free Tibet rally.

The Shambala of the Modern Times (2008), as well as other similarly styled pieces made since 2003 by Gyatso, borders on the profane with its mixture of thangka-derived religiosity and Pop Art appropriation. This is not simply an act of updating a traditional form to contemporary times. It is more akin to covering the exterior of a church in graffiti, thereby wrenching sacred, historical forms into the materialist, modish iconoclasm of the present.

The increasing intermixture—and sometimes estrangement—of religious practice and a culture of material consumption is a much-discussed topic in societies around the world that have seen religious worship rapidly change or diminish. In art, the intermingling of sacred and secular is a classic trope of American mid-century Pop Art, as in the Catholic, yet ersatz religiosity of Andy Warhol's *Gold Marilyn Monroe* (1962), as well as in the output of pop culture stars. The appropriately named, Catholic-raised Madonna, for example, became famous for controversial music videos such as *Like a Prayer* (1989), which features the singer kissing a handsome African-American Jesus who has come to life and stepped down from the cross.

What keeps Gyatso's artwork from approaching pop-culture cliché, however, is its refusal to present such experiences as the new normative condition. By preserving the traditional forms of thangka painting, such as the proportions, scale and iconography, Gyatso reaffirms the framework for the piece as rooted in tradition. The corrosive modern influences of consumerism, media and politics occupies the spiritual aura of the Buddha, supplanting religiosity with the signs of hyper-consumerism, but not disrupting the artwork's central form. It is still evident, when looking at the work, what is out of place and what belongs.

The element of critique in Gyatso's work was highlighted at the 2009 Venice Biennale, where *Shambala* was shown for the first time. Biennale artistic director Daniel Birnbaum positioned Gyatso's four-panel drawing on the opposite side of the brick-walled former shipyard from the German artist Thomas Bayrle, whose resurrected, 1970s-era wallpaper of a Chrysler car is made from tessellated shapes of the company's pentagonal logo. Bayrle's wallpaper and other large works at Venice, in retrospect, represented the redevelopment of German industry in the 25 years after the end of World War II in the same way that Gyatso's work marks the unequal and often awkward encroachment of global consumer culture, via the People's Republic of China, on Tibetan society in the two decades after the fall of the Soviet Union and China's embrace of market capitalism.

As politically fraught and contentious as the situation in Tibet is today, there is no lack of humor in Gyatso's work. *Shambala* was shown along with his series "Four Elements" (2009), in which a security camera or an Apple computer "power" switch is etched into the form of the Buddha's head. Even, or perhaps especially, for a non-Buddhist viewer, these forms feel somehow illicit, even sacrilegious. Gyatso is far from the only contemporary Tibetan artist who blasphemes against the tradition of thangka painting. Tenzing Rigdol puts Disney's smiling mouse at the center of a mandala, giving him wings in *Nya-ki-mi-key Mandala* (2008), and Gade, who is not included in "Tradition Transformed" though he is widely recognized in Lhasa for his early postmodern experiments, superimposes Mickey's demonically cheerful face onto four meditating Buddhas in his painting *Nirvana* (2006)—juxtapositions that have offended many Buddhist believers.

Among the currently active generation of Tibetan artists living in Lhasa, Beijing and Dharamsala, as well in New York, London, Zurich and Oakland, there is a pronounced tendency toward comedy in its myriad incarnations: black humor, satire, irony, absurdity, sarcasm and nonsense. Humor thrives on juxtaposed opposites: young and old, traditional and modern, romantic and bawdy, vulgar and sanctimonious. It frames these oppositions not as tragedy—like one's first reaction to the idea of a Lhasa McDonald's. Humor comes as a product of worldviews that remain at odds with one another, or at least those

impossibly awkward to combine, but which are forced together nonetheless. It has the potential to reflect the experience of those artists living abroad and increasingly those who remain in Lhasa.

In preparing this essay, I asked Tenzing Rigdol for some examples of Tibetan humor. He and his friend Thupten generously supplied those that appear in this essay, as well this explanation: "Traditional Tibetan jokes are normally found in religious scriptures (though many are claimed to be of an actual account) wherein jokes have a moral Buddhist message. So like all the traditional forms of art, jokes too illustrate religious doctrine."

The most traditional example that Rigdol and Thupten provided came with the following introduction:

Milarepa (c. 1052–1135 CE) is an enlightened philosopher, poet and vagabond who meets his sister, Peta, after many, many years of separation. At first she thinks that he is a ghost or a beast due to his long unkempt hair, protruding skull (due to malnutrition) and greenish, pale complexion. Nevertheless, Milarepa recognizes her and thereafter smiles at her. Peta, seeing Milarepa's smile, recognizes him from the shape of his frontal teeth [this could have lots of religious interpretations, but let's leave that out for now]. They were both very happy, and their meeting ends in joyous hugs and tears. Afterward, she realizes that her brother is wearing patches of torn rags. One could say that he was in a birth suit—almost naked with his private parts visible.

Peta: "Brother, I know that you are a great saint and a great philosopher but could you please manage to cover yourself with some decent clothes?"

Milarepa: "Peta, I am seeking enlightenment here. I do not have a single moment to waste. Clothes or no clothes, it really doesn't make a difference to me."

Peta: "But it does make a difference to me. I will go to the nearest town and beg for some cloth and please do make some sort of a dress that would at least cover your private parts."

Milarepa: "I will do it for you."

She hurries back to town and returns with donated clothing. She hands it to her brother and says she will be back very soon. After a few days she returns to him but to her surprise she sees Milarepa with his fingers and toes all covered with tiny pieces of the clothes that his sister brought from town. Along with the fingers and toes he has his private part also covered with a kind of tiny cap made out of the same material.

Peta: "What have you done? You have ruined my cloth! I asked you to make yourself a wrap-around cloth. You always say that you do not have a single moment to waste. See! You have not only wasted your time but also the cloth that I arduously begged for from door to door."

Milarepa: "Sister, sister, please, do not be mad at me. I was following your request. At first I was only working on my so-called private parts but the more I got involved, even my fingers and toes looked like my private parts [in Tibetan, the penis is called *pho-tson* ("male sign or signifier")]. So I ended up covering my fingers and toes too."

Peta: "Brother, you have really gone mad. You are hopeless."

Milarepa: "For those who surround me, I am a madman. For me, Milarepa, you all are mad."

Philosophers, literary critics and psychologists agree on little about humor's behavioral function or its evolution. But they concur on some of comedy's basic mechanics. Humor usually involves the clever merger of opposing concepts, and the undermining of prior presumptions. German philosopher Immanuel Kant, writing in *Critique of Judgment* (1790), believed that humor is "something absurd (in which the understanding, therefore, can find no satisfaction)," and thus results in the "sudden transformation of a strained expectation into nothing." Psychoanalyst Sigmund Freud proposed that the joke allows socially unacceptable thoughts—whether they are ribald, repressed, taboo, politically subversive—to be expressed in juxtaposition with conventional or familiar thoughts. Humor, for Freud, is a release of excess emotions, but it is "not resigned; it is rebellious." The psychologist also believed that "man adopts a humorous attitude toward himself in order to ward off possible suffering," making humor an antisocial or subversive gesture as well as a defense mechanism.

In its aggressive or defensive posture, humor puts the individual at odds with greater forces—divine, societal or governmental. But humor also provides individuals with empathy. In Freud's telling from 1927: "When, to take the crudest example, a criminal who was being led out to the gallows on a Monday remarked, 'Well, the week's beginning nicely,' he was producing the humor himself; the humorous process is completed in his own person and obviously affords him a certain sense of [rebellious and defensive] satisfaction. I, the non-participating listener, am affected as it were at long-range by this humorous production of the criminal; I feel, like him, perhaps, the yield of humorous pleasure." The revelation of the joke puts us and the criminal, however briefly, in an identical frame of mind. And as Freud's example makes clear, humor is effective even as a means of confronting death—a topic central to the thangka scrolls produced by generations of Tibetan artists.

LOL! The Buddha Embodies All, Derivative Trading, Too

The suffering and death that contemporary Tibetan artists confront has specific local and personal origins, as well as international relevance and parallels. Traditional Tibetan culture, as in other parts of the world, is imperiled by secular modernization, as well as by China's particular version of state-controlled capitalism. Tibetans must contend with Beijing's solutions to the province's supposed problem of a lack of modernization. As Beijing's newly appointed governor of Tibet, Padma Choling, insisted as recently as March 2010: "Only the Chinese Communist Party and socialism can save Tibet." Progress is only spoken of in economic terms, and yet, according to the Chinese, the main obstacle to Tibet's economic development and social progress is the Dalai Lama, the Tibetan's political and religious leader, whom Beijing reviles for his supposed advocacy for Tibetan independence. In fact, Tibet's indigenous culture is threatened by China's economic imperialism as well as ongoing "patriotic" reeducation campaigns that require Tibetans to denounce the Dalai Lama as their spiritual leader and seek to curtail religious practice—efforts that have been repeatedly renewed since the early 1990s—as well as giving up herding grounds, migratory lifestyles and ancient ritual practices deemed "backwards." It is world history repeating itself—from imperial conquests of Native American lands to the near-extermination of Indigenous peoples in Australasia—as central governments,

FIG 23

FIG 24

with often racist and prejudiced views, coerce ethnic groups into assimilation in the name of economic or social progress.

This dire narrative of an invading, imperial power forcing cultural assimilation on indigenous people is told without a single moment of humor by James Cameron in his blockbuster 3D film *Avatar* in which the fictional, pan-indigenous Na'avi people are attacked by an alliance of corporate-military interests. But the sanctimoniousness of Cameron's film is not the only way of broaching the subject. As Gonkar Gyatso's work indicates, many of the Tibetan artists in "Tradition Transformed" have responded with an initially surprising measure of humor, directing their satirical ire less at the People's Republic of China itself and more at the encroachment of global capitalism, of which Beijing and Shanghai are major centers.

The significant role that financial markets now play in most individuals' lives has left traces in several artists' work. Gonkar Gyatso's *Angel* (2007) **[FIG 23]**, which shows the iconic hooded figure from photographs taken of prisoner abuse by American soldiers at Iraq's Abu Ghraib prison, is dotted with the artist's colored stickers. The colorful figure stands on the outline of a lotus throne, with Avalokiteshvara, the Bodhisattva of Compassion, drawn in pencil behind the "Angel." The dotted lines and the scissors around the figures suggest you could cut out evil, represented by the hooded figure, and approach compassion. Surrounding the figures are smaller, cartoon-like drawings with small figures, as well as stock graphs and clippings from economics reports, including "Panicking investors fuel stock market fall," "the domino effect" and "Buy Now Pay 2088." The motif of the stock market as an indicator of mood, particularly irrational exuberance or catastrophe, is notable in this and other works. The rise and fall of prices on a chart has become an international language that, in Gyatso's case, can be used to express the anguish of political topics such as the US-led invasion of Iraq or the Chinese occupation of Tibet.

The enormous influence of financial markets, even in places geographically remote from finance centers such as Shanghai and Hong Kong, as well as their almost mystical intangibility, recurs again in Tsherin Sherpa's *Derivative 1* (2009) **[FIG 24]**. With a background of gold leaf, the painting shows the Buddha's head with a graph of the rising and falling prices of an unknown commodity or stock (as well as a portion of a graph showing the trading volume around the jaw line) taken from a computer trading screen. This nonsensical juxtaposition points to several false parallels between the karmic economy of Buddhism on the one hand, and, on the other, faith in the modern-day religion of economics, and in the "invisible hand of the market," whose mysterious ways are assumed by adherents to be as pure and unknowable as the natural laws of the universe.

Like Gonkar Gyatso, Sherpa has been immersed in two countervailing cultures. Sherpa lives in California, an American state known as much for its entrepreneurial spirit as its individualism and the prevalence of new-age spiritualism. In *Things That POP in My Head* (2009) **[FIG 25]**, a painting of the outline of a man with a large circle in place of his head, reminiscent of the aureola that surrounds deities, also metaphorically representing his consciousness, Sherpa provides the viewer with some autobiographical content. The circle is filled with signs—yin and yang, Shell Oil, the outline of an airplane, Tibetan script, the peace symbol, a large dollar sign, a smiley face, the recycling symbol, the Nike logo—interwoven with curving forms. With the cool irony of a pop painter, Sherpa

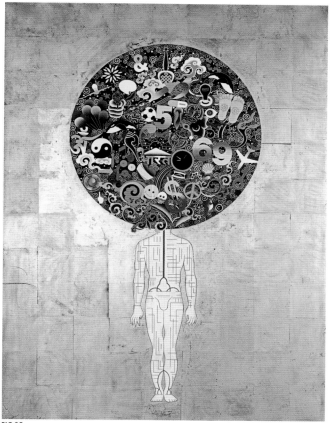

FIG 25

acknowledges the importance that the symbols of commercial branding play in his own consciousness. He even transposes the Tibetan motifs and script in his own head into the same style, implying a whole reorientation of his worldview.

A globe of circle-headed individuals with Shell Oil logos and musical notes rattling around at first seems benign and fairly comical. Our own heads may be filled with different symbols, but it is just as likely to be an eclectic mix. But in Sherpa's painting, one symbol stands out from the rest, once it is noticed: a hand holding a gun that is pointed at the viewer, implying that this symbolic infection of the mind by consumerism is accompanied, or enforced, by violence. Sherpa's painting is, to return to one of Freud's ideas of humor, a defensive reaction. The ironic juxtaposition of Buddha and derivatives trading, or Abu Ghraib prisoner abuse and cute stickers, is a thin mask for the emotional or existential difficulty of reconciling the disparities and contradictions of modern life.

Thangka Pop and Neo-Folk: Mickey, Mona and Barry O.

At the heart of a multicolored mandala, within the innermost golden ring, is a familiar face—not Buddha but Shepard Fairey's iconic (and plagiarized) image of US president Barack Obama. Tenzing Rigdol's *Obama Mandala* (2008) **[FIG 26]**—as in *Nya-ki-mi-key Mandala* (2008), a similarly pop-colored painting of a mandala with a head of Disney's iconic mouse adorned with wings on a lotus throne—places a contemporary "deity" at its center, as gods of old are replaced with present-day icons. The primary figures of the world's new popular culture are, in Rigdol's paintings, not individuals; rather they are widely circulated and heavily mediated images, as well as the subject of copyright infringement lawsuits. Painted in rich, flat colors, Rigdol's mandalas imply not a complex world of difficult spiritual challenges and treacherous distractions. Instead, the joke about Obama being like a god is nihilistic, or cynical, as an anodyne cheerfulness pervades the paintings, with no evidence that anything is in fact out of place.

For Rigdol, his modern mandalas are part of an examination of the hybrid mix of Western philosophy and art with Tibetan Buddhism and traditional art forms. Rigdol's term for his work is "fusionism," a theme that the artist has been working out in an ongoing series of works that looks at ideas of wholeness, or completeness. *Buddha-Ahh! Deconstruction Experienced* (2007) **[FIG 27]**, an orange-hued painting of Buddha sitting under the Bodhi tree beside a waterfall, takes its cues from thangka traditions as well as the French painter Fernand Léger's deconstructed, mechanical variant of cubism. The Buddha's fractured, square face and curly hair merge with the branches and roots of the tree behind him. In the lower left corner, he touches the ground with his right hand, a traditional motif representing Buddha's connection to the earth (as witness), and holds a skull bowl in his left. These elements, which Rigdol learned in his Tibetan studies, are fused with his understanding of modern and contemporary European philosophy, in which "deconstruction" (as both a literary and artistic theme) has come to represent the fragmentation of society and the loss of a unifying, cohesive worldview. If Sherpa and Gyatso, in their work, are unable to reconcile the extreme paradoxes of modern life, Rigdol has accommodated these disparities in an aesthetic that is, so to speak, "wholly fragmented." Instead of using satirical ire and sacrilegious juxtapositions, Rigdol's practice visualizes a more integrated way of seeing the world, an example of how irreverence can be constructive and healing.

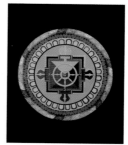

FIG 26

FIG 27

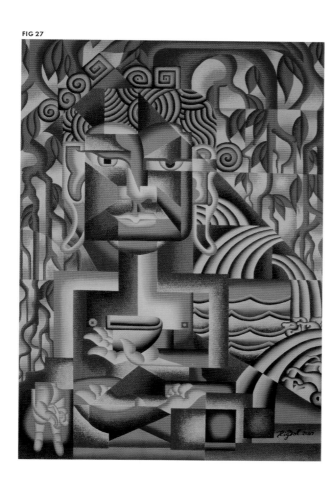

Rigdol's integration of forms has produced a wide variety of styles, such as *Fusion Tantra* (2008), in which the underlying grid of the thangka painting is laid bare as the artist applies colored patterning in particular portions of the canvas, leaving the rest of the composition drawn but unpainted. A formal experiment, *Fusion Tantra* (2009) shows Rigdol creating his own style that, while rooted in a traditional practice, has moved beyond the recycling or recombining of existing iconography into the creation of new, highly personalized hybrid forms, with their own popular appeal.

The creation of a strong personal style is also evident in the work of Dedron, who, though she has not lived outside of Asia for any long period of time, addresses global popular culture as a recurring motif in her work. In *Marilyn Monroe* (2009), Dedron paints the mid-20th-century American actress in purple, her head to one side, beneath the wreathing branches of a tree, a butterfly beside her. In *Mona Lisa With Pet* (2009) **[FIG 28]**, the figure of the famous painting has traveled to the Himalayas, where her pallid skin and oversized green eyes stand out from a cloud-covered mountainscape. The iconic figure holds a snow lion while a one-eyed, decoratively plumed bird rests on her shoulder and prominent cleavage. In Dedron's universe, Marilyn and Mona—iconic figures known to the world through moving and still images—are barely recognizable. Given a visual makeover, Marilyn and Mona are no longer alienated from their new surroundings. Dedron's paintings are metaphors for how elements of global culture are filtered, reimagined and reincorporated into a distinctly local context, a process that repeats Tibetan Buddhism's fusion of elements of native animist spirituality with religious teachings from Indian and Chinese Buddhist empires. Not traditional in their strict derivation from the formal lexicon of thangka painting, Dedron's works nonetheless embody the potential for generating new visual vernaculars that implicitly embrace societal changes.

Tradition Replicated:
Can You Ever Really Go Home Again, Even If You Want To?

Master: "Tashi, unload the saddle from our horses."

Tashi (servant): "Master, should I unload them from the horses with a vagina or the ones with a penis?"

The master gets angry and slaps the servant for his indecent use of language. Tashi is kicked out of his master's quarters.

As Tashi weeps outside the house, a nun sees him and interrupts, "What happened, dear?"

The servant explains all that took place inside the house, and in response the nun offers a piece of advice: "While referring to gender you could use words like male and female. In that way it becomes less vulgar."

The servant thanks her and reenters the room.

Tashi: "Master, I was asking if I should unload the saddles from the male horses or the females?"

The master is very impressed, and he asks, "Who taught you to talk in such a fine way?"

Tashi: "A monk without a penis!"

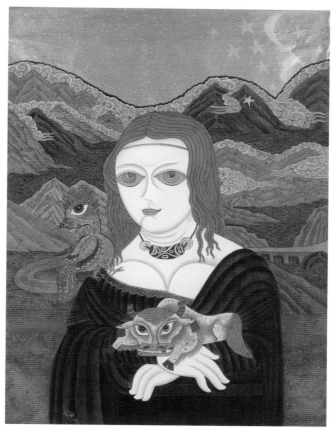

FIG 28

As society changes—for better and worse—so does art-making: a self-evident idea that nonetheless encounters resistance among those interested in hard-line versions of cultural preservation. A parody of this tendency is evident in Tsherin Sherpa's *Preservation Project #1* (2009), a gouache painting showing a glass jar that appears to contain the outline of the Buddha's head and a jumble of hands in different *mudras*, or the hand gestures of deities. The allegorical painting warns about the dangers of cultural preservation as a form of ossification or even death, as suggested by three flies on the outside of the jar.

Traditions, then, must be renewed, reinvented and reinterpreted in order to remain vital—although that path cannot be preserved or prescribed—and in touch with the audience that experiences them. Kesang Lamdark, the son of a reincarnated lama, is an artist who has lived all of his life outside of Tibet, while never losing touch with his Tibetan heritage, which he uses as an identity or a point of reference in his artworks. His effort to combine the experiences and values of two cultures yields a confrontational, bawdy humor. On his website, he identifies his work as "Neo-Tantric Art" and he calls himself a "Khampa Warrior," a reference to his family's origins in Kham, in eastern Tibet.

For the ShContemporary art fair in September 2008, Lamdark transported a 10,000-kilogram boulder (smuggled in the back of a truck) from his ancestral home of Garze, an autonomous prefecture in Sichuan province, to Shanghai. The rock was inscribed with the Tibetan mantra *Om Mani Padme Hum*, or "Om, Jewel in the Lotus, Hum." Once in Shanghai—getting there required bribing military officials to allow the rock out of the heavily militarized prefecture of Garze—Lamdark, standing on ladders in the hot Shanghai sun, melted bubble-gum pink plastic sheets over the rock to create *Pink Himalayan Boulder* (2008) **[FIGS 29, 30]**. A patently absurd project in its ambition—the expended energy, human and mechanical, of transporting a rock across half a continent—the boulder became a remarkably poignant conundrum in its final form, estranged from its natural environment, coated in lurid pink synthetic material and inscribed with a Tibetan phrase strongly associated with admirers of the Dalai Lama.

In more recent works, Lamdark has melted vividly colored plastic sheeting over underlying forms created in wire. In both *Blue Tara* and *Pink Tara* (both 2008) **[FIG 31]**, plastic sheets are melted over chicken-wire forms of the female Buddhist deity Tara, who is often characterized in traditional thangka by the color in which she is depicted. Inside each of Lamdark's "Tara" sculptures is a fluorescent light, transforming the image into something kitschy, similar to the illuminated flamingos sold in hardware stores as lawn decorations. His series of "Vests" (2006–08) are modeled on the sleeveless garments worn by monks, but with their gaudy, bright colors and shiny plastic veneer, they look as if they could be worn to a nightclub. Lamdark has also combined plastic with horse dung in *Dwarf of the Golden Horseshit* (2007), 11 clumps of horse excrement covered in golden plastic, and one pile of melted plastic shaped like a midget with a gold-covered baseball cap. These pieces have a kind of ironic beauty—an allure that stems from the cheapness of their materials—that is fiercely irreverent.

Irreverence, to both Western art history and Tibetan heritage, is a central element in Lamdark's work that—counterintuitively—feels nonetheless like an homage to his heritage. The socially unacceptable (transforming sacred religious icons into cheap plastic sculptures), or politically taboo (hauling rocks from Tibet) are all subsumed in Lamdark's eccentric use of melted plastics and other odd materials, such as used

FIG 29

FIG 30

FIG 31

beer cans, which can alternately distract or enhance the subjects of his work, allowing subversive messages to slip in.

Between a Rock and a Hard Place:
Tibetan Artists and Their Regional Peers

The juxtaposition of traditional art forms and the symbols of modernity is a widely employed visual and aesthetic trope, not just in contemporary Tibetan art but also in the work of regional counterparts. Although throughout its history Tibet has drawn influence from both the Chinese empires to the east and Indian civilizations to the south, contemporary artists of Tibet show relatively little artistic influence from either country, even though the modern nations of China and India are home to several of Asia's largest art communities and cultural economies, particularly in the cities of Beijing and Shanghai, and New Delhi and Mumbai.

Among the many economic, political and social reasons for the lack of sustained dialogue between, for example, New Delhi and Lhasa, or Beijing and Lhasa, is that the contemporary art scenes of China and India developed decades before Lhasa's, occurring primarily in the 20th century, placing the current growth of Tibet's art scene in a different context from that of either country. In the case of China, the first cohort of postmodern artists, the so-called '85 New Wave, emerged in cities throughout the country (later consolidating in Beijing and Shanghai) beginning in the early 1980s. This generation of artists, even before the Tiananmen Square protests of 1989, had 40 years of suppressed history to reckon with, including the Great Leap Forward (1958–61) in which 30 million people died in famines, the Cultural Revolution (1966–76) and other disruptive ideological movements and campaigns, as well as the rapid but less ruthless transition from Maoism to market economics beginning under Deng Xiaoping in the late 1970s.[3] The works of these artists from the 1980s—expressionistic, calligraphic installations filled with large, invented or miswritten characters by Gu Wenda, Wu Shanzhuan, Xu Bing and the Xiamen Dada collective, as well as absurdist and mystical sculptures by Cai Guo-Qiang, Huang Yong Ping and Chen Zhen—subverted the Social Realist tradition promulgated in art academies, as well as the generic standards of Communist propaganda. Chinese artists of the early and mid-1980s looked back at older Chinese—as opposed to strictly Communist—visual traditions.

The works of contemporary Chinese art that come closest to the juxtapositions and manipulations of visual codes found in contemporary Tibetan art are the Political Pop paintings of Wang Guangyi. Beginning with his controversially ambiguous depictions of Mao in the late 1980s, Wang married consumerism and "tradition imagery"—here Maoist propaganda—culminating in his "Great Criticism" series of the late 1990s, in which armies of workers and loyal partisans are paired with the logos of Rolex, BMW, Chanel and Coca-Cola, signaling the often incongruous-seeming shifts in Beijing's stance toward capitalism.

In India, by contrast, contemporary artists drew from a long tradition of modernist painting and sculpture, which dated back to the late 19th century but gained international recognition in the work of the Progressive Artists Group.[4] Started in Mumbai at the time of India's independence from Britain in 1947 by a group of Sir JJ School of Art

graduates, the Progressives, included the figurative painters FN Souza, MF Husain, abstractionist SH Raza and, later, sculptor SK Bakre and painter Tyeb Mehta. In their individual practices, the Progressives fused European modernism with the history and culture of the Subcontinent. Souza, for example, brought Picasso-style cubism to his portraits; Raza used the motif of the *bindu* in his abstractions; and Mehta employed figures from Hindu mythology in his allegorical paintings. The relationship of Indian artists in the 1980s and 1990s, who worked in the postmodern genres of performance, video and installation, was similar to that of European and North American artists of the same period, having learned modernism in school and through the works of their predecessors. Whereas the early Indian modernists broke with society's conventions and expectations, postmodernists simply parted ways with the modernists, taking up new media as well as political and social topics. Contemporary Tibetan artists of the past decade, without a comparable history of modernism—which in India was also deeply intertwined with the country's independence and evolution as a nation—are the first generation to break definitively from tradition; yet they are not overtly shouldering the nationalist or radical social agendas taken up by numerous factions of the 20th-century European and American avant-gardes.

Tibetan artists, rather than exhibiting overt similarities to artists of its two large neighbors, share traits with their peers in Pakistan, Iran and Thailand—countries with strong artistic traditions but whose domestic cultural communities underwent fewer, or more sporadic, developments in the 20th century.

Lahore, at the western end of the Himalayas, nearly 1,600 kilometers from Lhasa, is the largest city in northern Pakistan. A Buddhist outpost in the fifth and sixth centuries CE before the invasion of Hindu and Muslim tribes, Lahore was one of the many centers for the 16th- through 19th-century school of Mughal miniature painting. Many of the city's contemporary artists, particularly those trained at the National College of Arts (NCA), are steeped in this visual tradition. In the past two decades, graduates from the NCA's miniature painting department have included Imran Qureshi, Aisha Khalid, Nusra Latif Qureshi and Shahzia Sikander. These artists, and other NCA graduates, have continued to paint in the vein of the Mughal miniature tradition, adapting compositions, materials and themes into contemporary art works, often with irony and wit. In particular, Imran Qureshi's series "Moderate Enlightenment" (2007–09) hews closely to the conventions of miniature painting, with a central figure set in a stylized landscape. But Qureshi's figures are nonetheless modern men and women, as evidenced in various works from the series by the patterned pair of socks worn by a reclining poet, the barbells flexed by a standing man, a young woman's fashionable hoodie sweatshirt and jeans, and the shopping bag held by a man in T-shirt and shorts. Qureshi's subtle, sneaky juxtapositions demonstrate how products of global consumerism have insinuated themselves into even the most traditional societies.

The juxtaposition of modern materials or consumer goods with traditional art forms has become an insidious cliché in the work of many contemporary artists from Asia and what the European and American art world condescendingly considers "emerging" art markets. As an artistic strategy, depicting how the traditional clashes with the modern has proven to be commercially successful, which, given the international art market's primary clientele of the world's super-wealthy, is perhaps no surprise. Whether produced

in Indonesia or Nigeria, such artworks validate the incredible power of free markets to create desire and demand for consumer goods. But an equally universal phenomenon of this decade is the critical backlash faced by these art-market winners for the perceived simplicity of their works, their pandering to the tastes of international collectors and their uncritical stance on the politics of globalization.

Many talented artists—some deliberately, others unwittingly—have built their international careers on the back of this flashy "tradition-meets-hyper-modernity" strategy. One of the art world's best examples is the Iranian-born, multitalented Farhad Moshiri,[5] whose 2007 black canvas spelling out the Farsi word *Eshgh* ("Love") in Swarovski crystals and golden glitter, sold at Bonham's Dubai in March 2008 for a record price that just surpassed the USD one million mark, including the buyer's premium.[6] For artists seeking commercial success, Moshiri's career serves as a cautionary tale, as his name has become associated with high prices rather than quality or diverse artwork. Recently given the dubious title of "the Andy Warhol of the Arab art world" by the Middle East-focused *Bidoun* magazine, Moshiri, like his American aesthetic cousin Jeff Koons, creates paintings and sculptures that play the awkward and often humorous role of confronting viewers with symbols of extravagance, luxury and mega-wealth, in a deliberately ironic or willfully naive package. This attitude of faux-impassivity on the part of the artist is played up in Moshiri's sequin-embossed *Self Portrait* (2006), in which the artist depicts himself as a boy sitting on a tree stump, sketching a bird, as a crow and pink bunny hold his paintbrushes. But in fact, the artist's installations of gilded furniture, paintings of cracked ceramic pots covered in Farsi calligraphy, Persian rugs cut into the shapes of airplanes ("flying carpets") and crystal diamond maps of the world, walk the narrow line between representations of the gaudy taste of the nouveau riche and a high-brow form of pornography that glamorizes (with an ironic wink to those who know better) the very kitsch that an educated eye is meant to scorn.

Pop art—its iconography, its deadpan humor, its often ambiguous relationship to the subject of its parody—is a global phenomenon. Like its primary subject, consumer capitalism, pop takes on local characteristics, integrating itself into existing aesthetic traditions. But for Tibetan artists, it is not the only tendency shared with regional peers. Part of what makes a Tenzing Rigdol or a Gade painting humorous is the self-conscious joking on the part of the artist about the attributes of Tibet-ness—as when Rigdol uses the sanctity and centrality of the Buddha in Tibetan art to confer similar status on Mickey Mouse. This ironic referencing of national or ethnic characteristics, which at times borders on the stereotypical, is shared by many contemporary artists in Thailand—perhaps not coincidentally another Buddhist-majority country currently embroiled in a power struggle over the country's modernization and participation in the global economy.[7]

Visitors to the Venice Biennale in 2009 saw billboard posters throughout the island city that read: "Art is Rice and Watermelon" or "Art is Rice and Papaya Salad," which in fact were advertisements for the Thai Pavilion, a mock travel agency-cum-exhibition venue called "Gondola al Paradiso Co., Ltd."[8] Thailand's reputation as "exotic" and its allure for tourists has been a recurrent theme at the country's official Venice pavilion since its first appearance at the 2003 Biennale in Apinan Poshyananda's "Reverie and Phantasm in the Epoch of Global Trauma," a show looking at how seven Thai artists were responding to Southeast Asia's twin identities as tourist destination and terrorist haven.

The topic of Thai-ness has such current interest that the country's first contemporary art venue, the Bangkok Art and Culture Centre, organized "Traces of Siamese Smile: Art + Faith + Politics + Love" as its inaugural contemporary art exhibition in September 2008 with 300 Thai and international artworks that looked at the country's welcoming, hospitable facade. Even Thailand's best-known international artists tend to riff on stereotypes of Thai-ness. Rirkrit Tiravanija is known for staging casual social events, such as emptying a gallery space of all its contents and conventing a museum into a 24-hour living area as well as cooking curry and *pad thai* for gallery visitors, and displaying the remnants of these performances. Sakarin Krue-on (also one of the organizing artists of the 2009 Venice Biennale pavilion), at documenta 12 in Kassel, Germany, in 2007, constructed a rice terrace in front of the city's Wilhelmshöhe Castle.

Such recycling and repurposing of cultural tropes, like the appropriation and juxtaposition of traditional and pop imagery, also runs the risk of reenforcing the very stereotypes being targeted for criticism. This is a particular concern in an international art context in which viewers are quick to see an artist's nationality first and, often knowing little about the artist or country itself, are slower to appreciate the elements of absurdity, irony or sarcasm.

While contemporary Tibetan artists are likely to have encountered these expectations already in the international art world, their position is neither wholly unique nor universally shared. Tibetan artists, in their relationship to China, are in a similar social position as that of Indigenous Australian and Maori artists in relationship to the white European-majority societies of Australia and New Zealand, respectively.[9] Both Australasian indigenous populations (and the multiplicity of communities within each) were systematically pushed to near extinction by the colonizing British Empire and later by the independent governments of Australia and New Zealand beginning in the late 19th-century. Like living Tibetan artists, contemporary artists of Indigenous and Maori descent have long and rich visual cultures to draw on, and many still work in traditional styles, while others have adopted a contemporary or postmodern approach that incorporates elements (patterning, iconography, myths) of Aboriginal cultures.

In trying to strike a balance between winning recognition of the plight of Indigenous peoples, and creating cultural space to discuss a history that the majority of white Australia would prefer to forget, Indigenous artists face two problems. The first is the issue of tone—how does an artist express anger and outrage without immediately alienating the audience such that their (legitimate) claims are not even heard? The second is the difficulty of working in a specific local context—how does an artist from a minority population, whose points of cultural reference are seen by the majority as parochial, free themselves from cultural marginalization without abandoning pressing political topics?

There are no obvious solutions, but a couple of generations of Indigenous artists offer a range of possibilities. Among those who have adopted a strident, political tone, are Richard Bell, known for his text paintings, most famously *Scientia E Metaphysica (Bell's Theorem)* (2003) in which the words "Aboriginal Art: It's a White Thing" are incorporated into an abstract patchwork of linear designs, bordered by the red outline of a triangle and covered in Jackson Pollock-esque trails of black and white paint. In

1995, to escape the strictures of the Aboriginal artist label, Gordon Bennett—whose own eclectic paintings appropriate a range of visual imagery from Desert Art to Jean-Michel Basquiat—created an artistic alter ego, John Citizen, whose illustrative paintings show Aboriginal-looking abstractions in generic domestic interiors. In the black text on white canvas works of Vernon Ah Kee, the issues are often laid out clearly, as in his four-line run-on text work *Acceptance* (2006), which reads: "myduty/istopersecuteerror/ yourdutyistoaccept/truth."

Whereas Ah Kee's statements often possess universality, other Indigenous artists have gone further to point to the connection between their history and that of other persecuted minorities. Tracey Moffatt, who throughout a 20-year career has rejected the role of social commenter or her art's ability to correct individuals' biases, has instead put her work in an international framework; her films, videos, photographs and paintings depict the racial prejudices held against minorities around the world. As she wrote about a series of archival-looking photographs from a 2010 exhibition in Sydney: "I want the photos to . . . look like they could have been shot in Australia's tropical north, or the Caribbean, or the Deep South in the US, or somewhere in South East Asia. Or possibly Africa."[10]

Imperfect and brief as these comparisons are, their purpose is to illustrate that while contemporary Tibetan artists are distinctive, even in the context of Tibet's insularity and the culture's relationship to artistic traditions, Tibetan artists are not the only artists regionally or internationally who are wrestling with how to express their historical relationship to once-sacred aesthetic traditions and how that cultural history does, and does not, accommodate modernization. That is precisely why the Swedish-born curator of the Venice Biennale, Daniel Birnbaum, could put paintings and collages from the 1970s by a (West) German artist, Thomas Bayrle, across the Arsenale hall from new works by Tibetan-born Gonkar Gyatso, and produce a curatorial dialogue or coherence between two artists who otherwise may never have encountered each other.

Post-Thangka Internationalism

If the experience of artists from other Asian countries is any indication, an even younger generation of contemporary artists from Tibet and the diaspora is likely to chafe at the expectations that come with the label of being a Tibetan artist. Critics, curators and gallerists will try to read their presuppositions about Tibetan culture into their artwork, even if it is devoid of thangka-derived iconography.

Even as younger Tibetan artists resist such ethnic-based labels and expectations, future cultural developments in Tibet might have the opposite effect, compelling artists to reclaim or celebrate their heritage. Lhasa, subject to Beijing's decisions but with popular loyalty still devoted to the exiled Dalai Lama, will likely remain contested ground, and risks to the survival of Tibetan culture and Buddhism will remain high. The selection of the next Dalai Lama remains a source of much political and emotional speculation, as Beijing may decide to pick its own Lama, forcing Tibetans to worship a Party-picked leader as they have done with the Panchen Lama. On March 10, 2010, the Dalai Lama himself expressed the widely held anxiety that Beijing was trying to annihilate Buddhism.

The current conditions for Tibetans in Lhasa and the region, in short, are likely to remain the same or get worse as Beijing's economic modernization agenda is met by an increasingly desperate, angry backlash. Whether the good humor of young Tibetan artists will survive or even flourish as a mode of resistance or self-preservation will be worth watching. Or will the generous, reflective humor evident in the jokes supplied for this essay also be lost, or soured?

The inability to determine the future, despite the best intentions, is the subject of this final joke:

A monk walks toward a house to collect his daily alms. A woman answers the door.

Monk: "Please grant me something to eat."

Woman: "Hey, mendicant! I have a request for you."

Monk: "I will do everything that I can, madam!"

Woman: "I will give you three options. Sleep with me, slay my yak or drink a bottle of wine."

Monk: "I really cannot do any of these for I would be breaking my monastic vows."

Woman: "If you refuse to do any one of these then I will commit suicide."

Facing such a dilemma, the monk chooses to drink the wine, for it is the least serious among all the negative actions, according to the rules of monkhood. The next morning, he wakes up with a hangover and to his surprise discovers that he is sleeping next to the woman. As he rushes out of the room, he sees the yak, beheaded in the yard.

HG Masters is an artist, writer and editor-at-large for ArtAsiaPacific *magazine.*

1 The jokes in this article were generously provided by Tenzing Ridgol and his friend Thupten. They have been edited only to improve the phrasing as well as to correct the grammar and punctuation.

2 The Dalai Lama and supporters did successfully keep KFC from opening in Lhasa in June 2004. Their objections were primarily over the mass slaughtering of chickens that would be required, and that chicken is not traditionally a Tibetan meat.

3 These events also impacted life in Tibet; but arguably the question of whether Mao's legacy was defensible or not would have been entirely different to a Chinese resident of Beijing, for example, than to a Tibetan living in Lhasa.

4 Partha Mitter offers the most comprehensive guide to pre-Progressives Modernism in India in *The Triumph of Modernism: India's Artists and the Avant-garde*, 1922-47 (Reaktion Books, 2007), paying particular attention to Amrita Sher-Gil, Rabindranath Tagore, the Bengal School and Jamini Roy.

5 Two recent profiles of Moshiri, "Fluffy Farhad" by Negar Azimi in *Bidoun* 20 (Spring 2010), and "Less Than Zero" by Elaine W. Ng in *ArtAsiaPacific* 68 (May/June 2010), both affirm his critical stance on the proliferation of nouveau-riche culture, in Iran and internationally, in the decade of the 2000s. However, Azimi's piece also documents the hostile reactions to Moshiri's works from his peers, including Fereydoun Ave's stinging critique that Moshiri's works shown at the 2009 Frieze Art Fair were "toys for the anaesthetized new rich."

6 It's worth noting, to avoid mindlessly repeating the corporate PR, that the hammer price was $900,000 and that Bonham's included the 16-percent buyer's premium in the price of the painting to achieve the benchmark-passing price of $1,048,000. Also note that in March 2008 the US dollar was, at that time, at its lowest exchange rate against the euro in the entire decade.

7 For the definitive history of Thai modernism, see Apinan Poshyananda's *Modern Art in Thailand: Nineteenth and Twentieth Centuries* (Oxford University Press, 1992).

8 Writing a preview of the 2009 Thai Pavilion in *ArtAsiaPacific* 63 (May/June 2009), Bangkok-based critic Philip Cornwell-Smith observed: "Thai-ness has become the hottest topic of Thai art, driven by the frisson of taboo."

9 I owe the inspiration for this comparison to two recent essays written by my *ArtAsiaPacific* colleagues: Don J. Cohn, on the work of Vernon Ah Kee, Tony Albert, Gordon Bennett, Shane Cotton and others, to be published in a forthcoming catalog for the Roundabout collection; and to Ashley Rawlings' mid-career overview of Brook Andrew in *ArtAsiaPacific* 68 (May/June 2010).

10 Artist's statement on *Plantation* (2009), shown at Roslyn Oxley9 Gallery, Sydney, in April 2010.

Dedron

བདེ་སྒྲོན་

bde sgron

Born in Lhasa, Tibet, in 1976, Dedron graduated from the Art Department of Tibet University in 1999. One of the few artists in "Tradition Transformed" who did not train in classical Tibetan art, Dedron is a member of the China Minority Art Association and the Gendun Chöpel Artists' Guild, both of which are located in Lhasa. She has participated in group exhibitions at museums in Beijing, Shanghai, Guangzhou, Kathmandu and Singapore. Her work can be found in the collection of the Li Keran Art Foundation in China, as well as in private collections in the UK, the US, France and Germany. The artist lives in Lhasa.

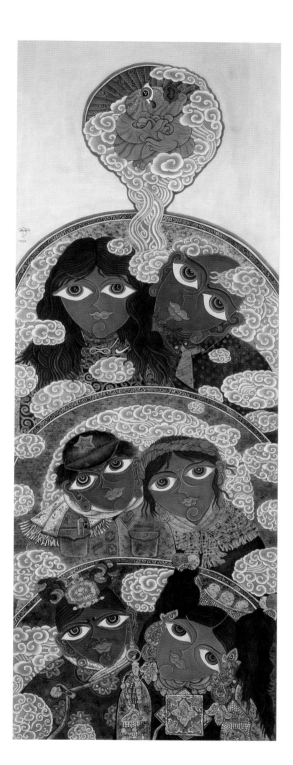

Grandparents–Son, 2010

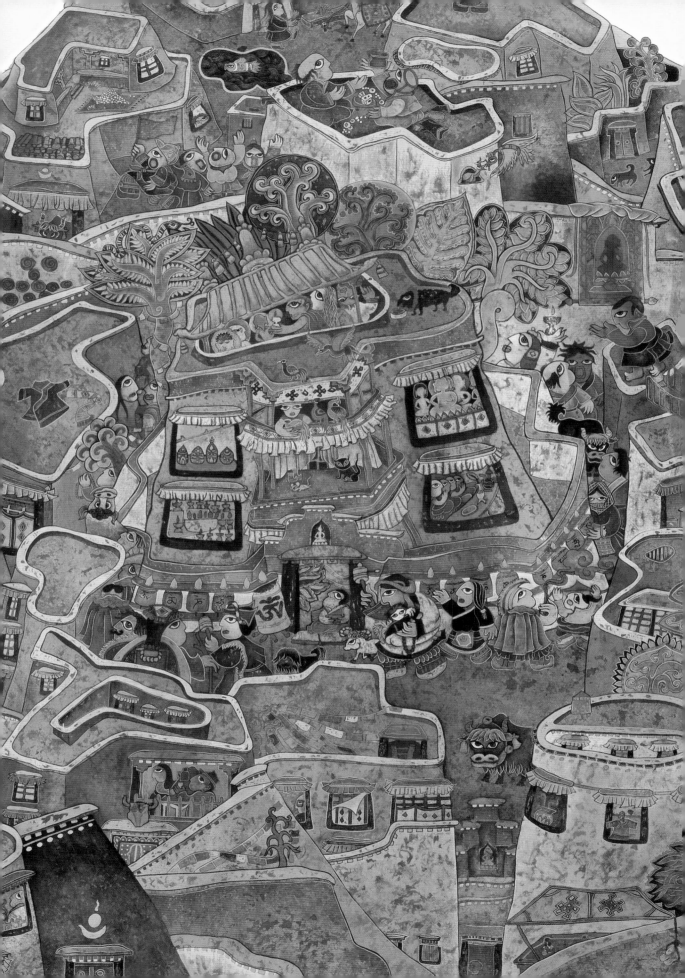

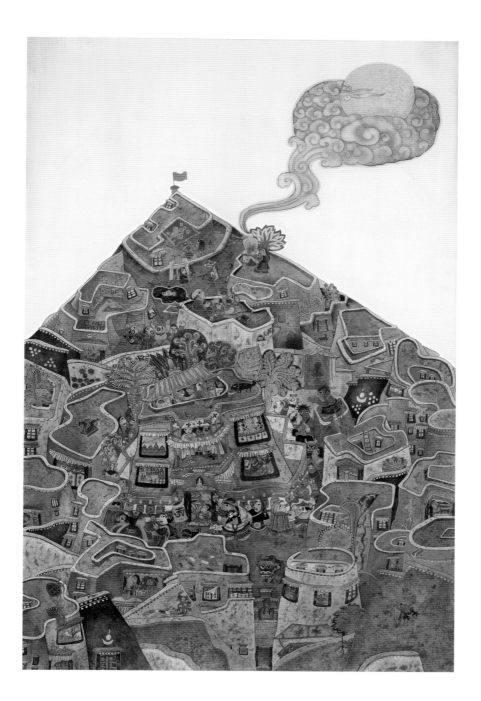

Gonkar Gyatso

གོང་དཀར་རྒྱ་མཚོ

gong dkar rgya mtsho

Gonkar Gyatso was born in Lhasa, Tibet, in 1961. He studied fine art in Beijing at the Central University for Nationalities from 1980 to 1984, and received his MA in 2000 from the Chelsea College of Art & Design in London. In 2003, he founded the Sweet Tea House in London, the first gallery in Europe devoted to showcasing contemporary Tibetan art. Also in 2003, Gyatso received a Leverhulme Trust fellowship to be an artist-in-residence at the Pitt Rivers Museum in Oxford, England. He has exhibited internationally in galleries and museums, including the National Art Museum of China in Beijing, the Kangra Museum in Dharamsala, the Gallery of Modern Art in Glasgow, the Courtauld Institute of Art in London, the Wereldmuseum in Rotterdam and the Colorado University Art Museum in Boulder. The artist's mixed-media works were featured in the Arsenale at the 53rd Venice Biennale in 2009 and in the 17th Biennale of Sydney in 2010. Gyatso's work is held in the permanent collections of the Newark Museum in New Jersey, the Pitt Rivers Museum in Oxford, the World Museum in Liverpool, the Queensland Art Gallery in Brisbane, the Devi Art Foundation in Gurgaon, India, as well as in numerous private collections. He is based in the UK.

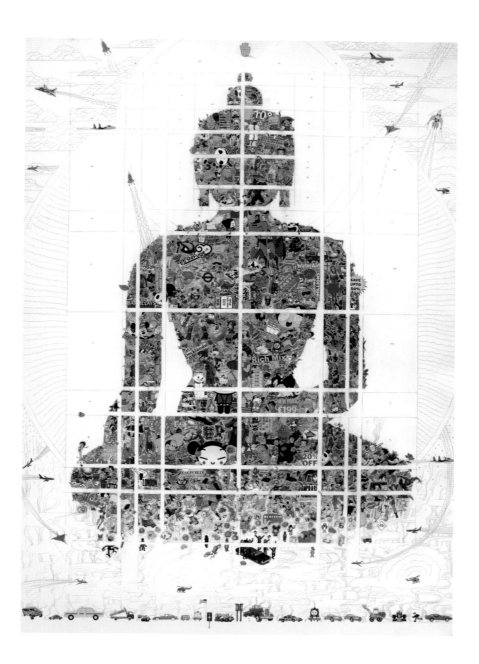

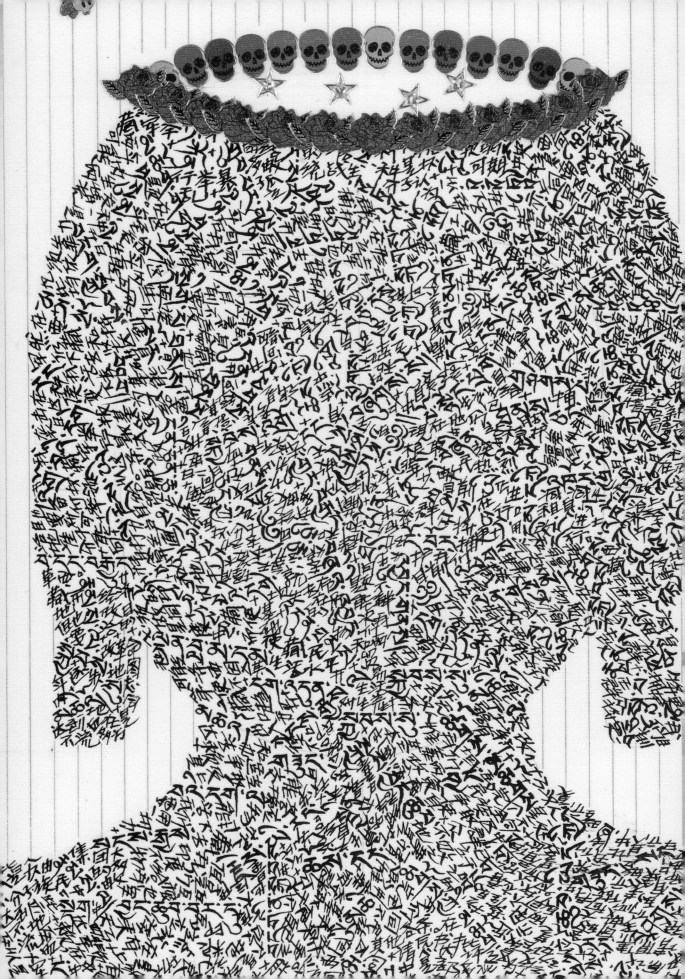

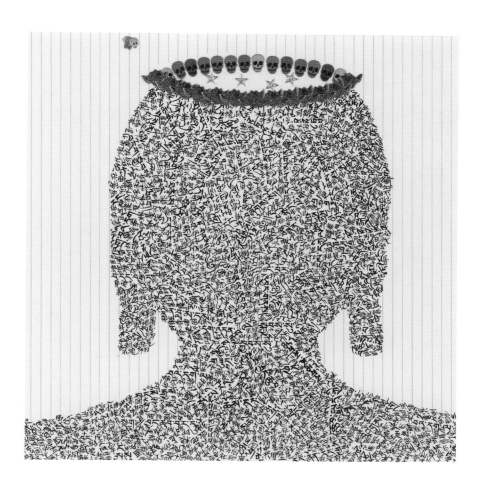

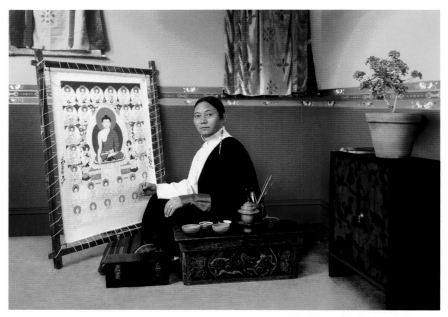

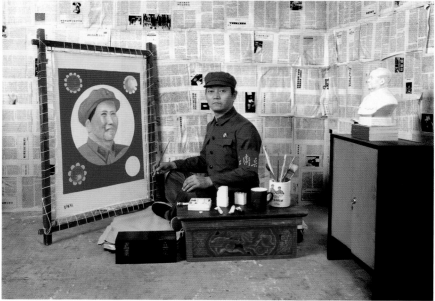

[Bottom] My Identity 2, 2003. [Top] My Identity 1, 2003. [Following Detail]

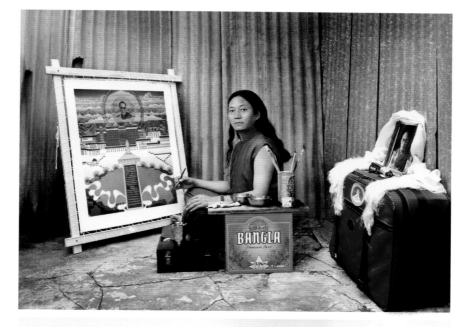

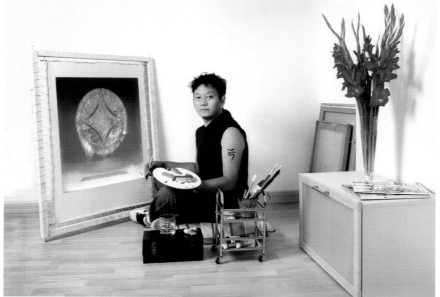

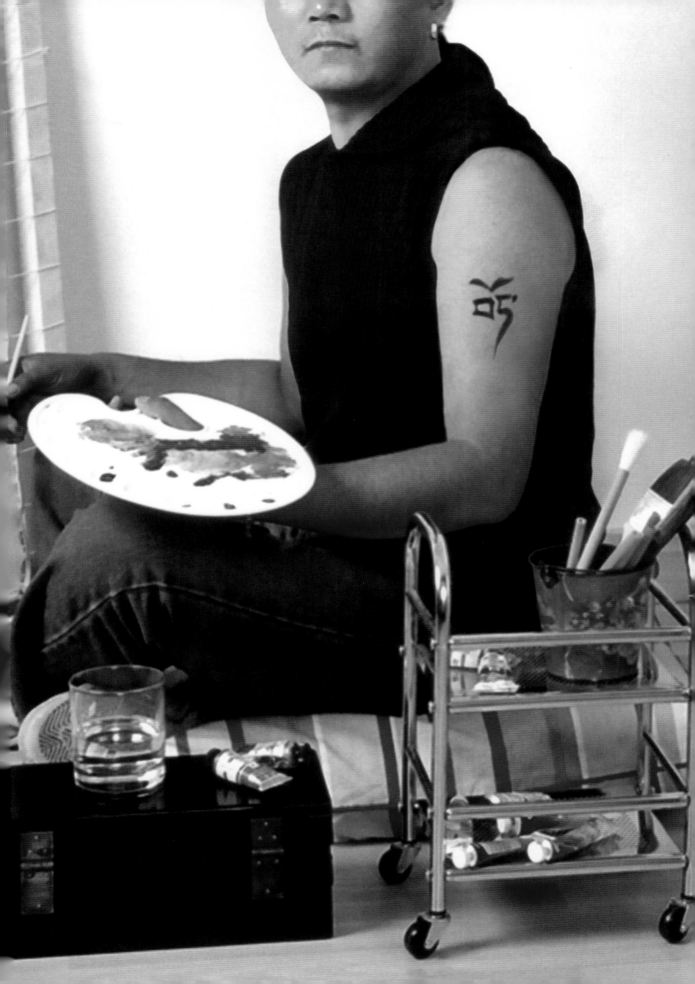

Losang Gyatso

བློ་བཟང་རྒྱ་མཚོ།

blo bzang rgya mtsho

Losang Gyatso was born in 1953 in Lhasa, Tibet, and was raised and educated in the UK and the US. In 1978, after finishing his studies at San Francisco's Academy of Art University, he moved to New York to pursue a career in advertising. He began making art in the early 1990s with the intention of visually recording his experiences and ideas on Tibetan aesthetics, and has experimented with diverse materials. Gyatso has designed books and logos for several organizations including the International Campaign for Tibet, the Tibet Fund and Machik. In 2001, in an effort to create a network for Tibetan artists, he founded a website that has evolved into the Mechak Center for Contemporary Tibetan Art. The Mechak Center has organized exhibitions and symposiums on contemporary Tibetan art, including "Waves on the Turquoise Lake: Contemporary Expressions of Tibetan Art" at the University of Colorado in 2006. He has exhibited widely in the US and Europe, and lives outside Washington, DC.

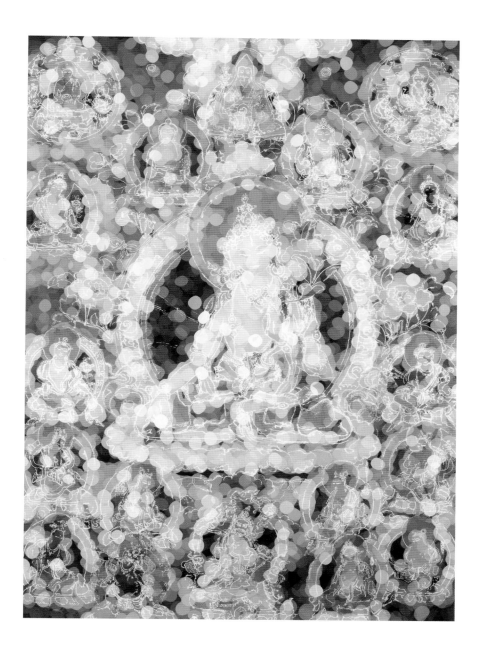

Clear Light Tara, 2009; [Following] Detail

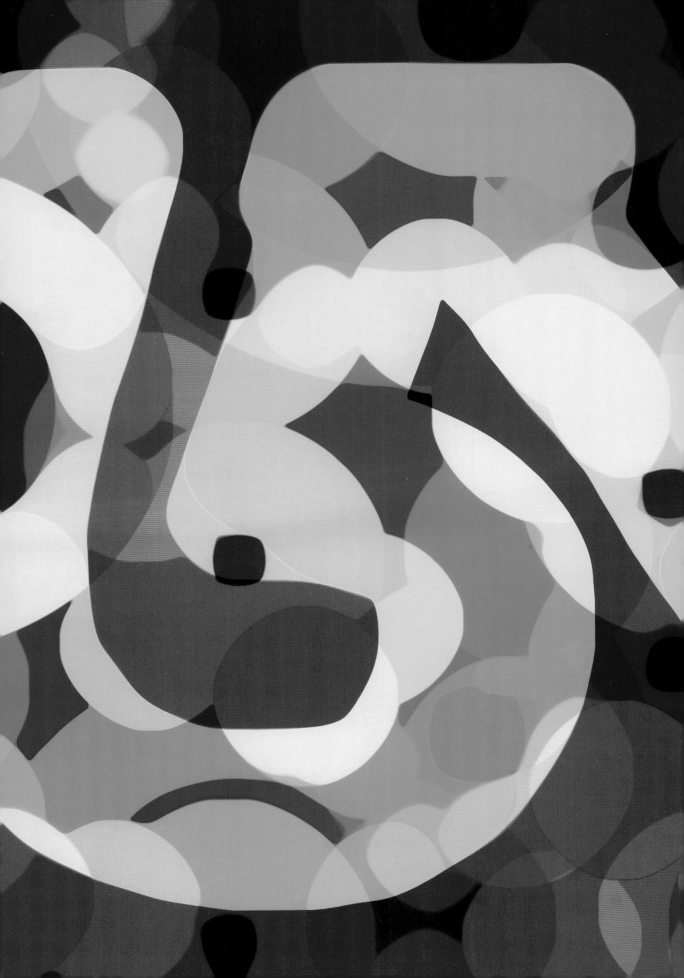

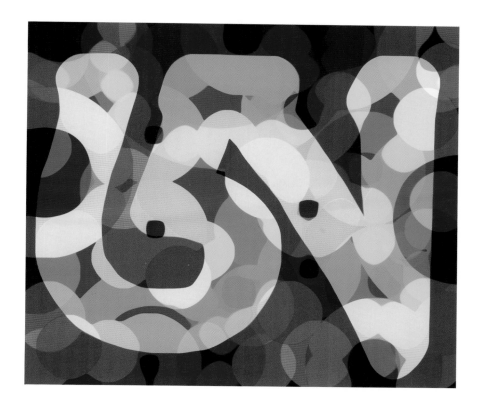

Green Zone of Amoghasiddhi, 2007; [Facing] Detail

Kesang Lamdark

 སྐལ་བཟང་ལམ་བྲག

skal bzang lam brag

Kesang Lamdark was born in Dharamsala, India, in 1963 and grew up in Switzerland. After apprenticing and working as an interior architect in Zürich, he studied art at the Parsons School of Design in New York from 1991 to 1995, and received an MFA in 1997 from Columbia University in New York. His multimedia sculptures and installations, made from diverse materials including plastic, metal, lights and found objects, reflect both his Tibetan heritage and his upbringing in Europe. Lamdark has exhibited in gallery and museum exhibitions in Europe and the US, and participated in the Third Guangzhou Triennial in 2008. The artist lives in Zürich.

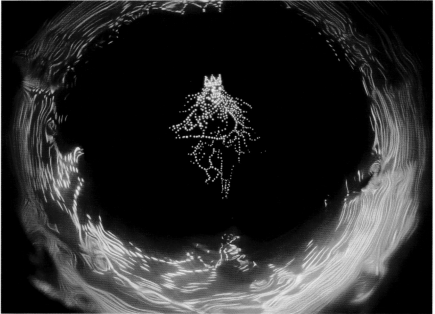

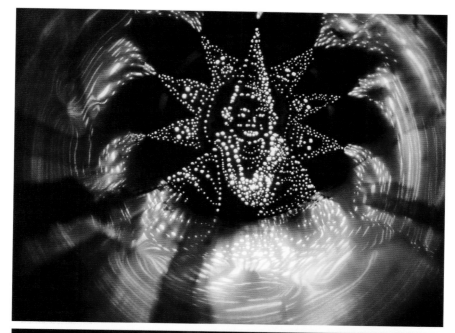

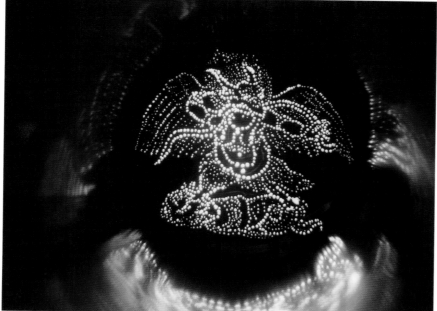

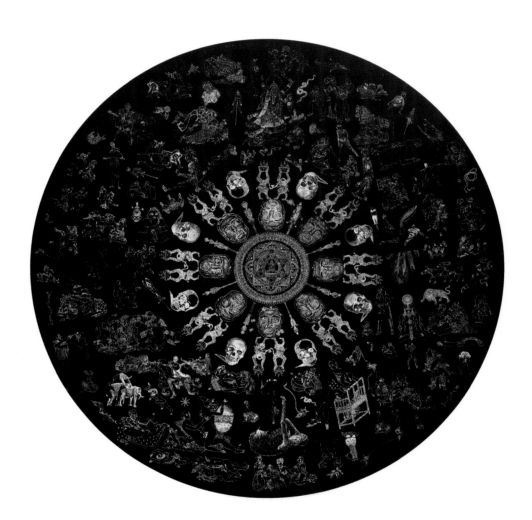

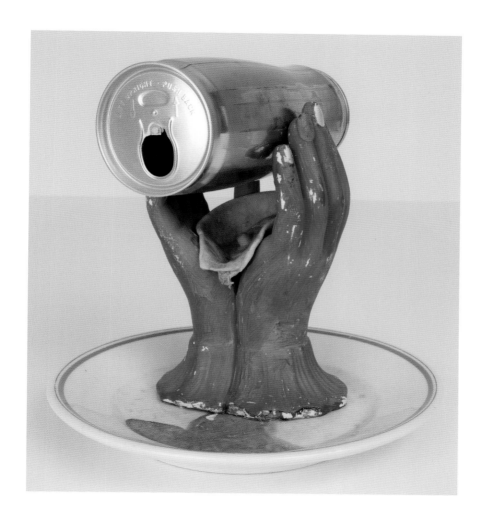

Tenzin Norbu

བསྟན་འཛིན་ནོར་བུ།

bstan 'dzin nor bu

Tenzin Norbu was born in 1971 in Dolpo, Nepal, into a family of painters whose lineage stretches back more than 400 years. Norbu is well known in Nepal for his fusion of traditional art and contemporary illustration in his innovative rendering of landscapes, many of which feature scenes of traditional life in the high Himalayas. Norbu's work has appeared in many international publications, including *Caravans of the Himalaya* (National Geographic Society, 1995), *National Geographic* magazine, as well as in the feature film *Himalaya*, which was nominated for an Academy Award in 1999. He has also illustrated four children's books. Along with photographs by Eric Valli, director of *Himalaya*, his work was featured in a major 2002 exhibition at the Luxembourg Gardens in Paris. The artist is also actively engaged in preserving the traditions of his isolated homeland. He founded the Kula Ri Mountain School in his native Panzang Valley, creating educational opportunities for the children of this remote region. His work is currently held in many private collections and museums. Norbu divides his time between the Dolpo region and Kathmandu.

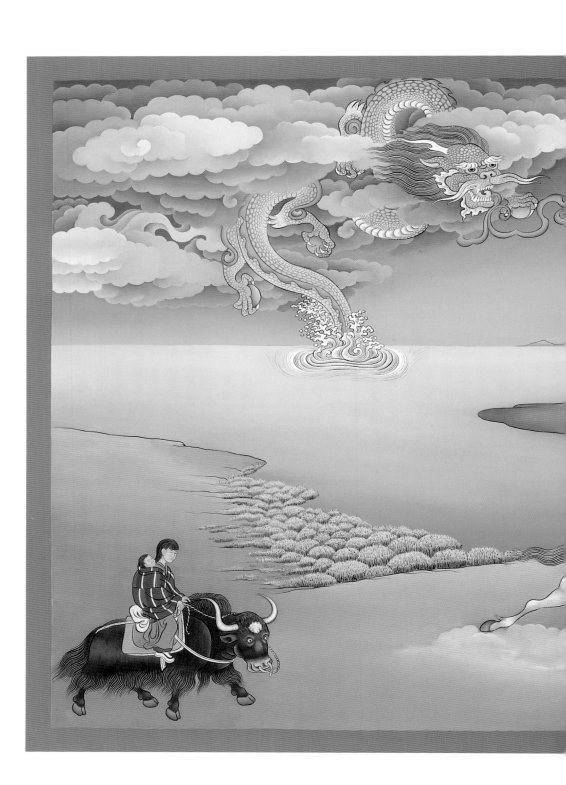

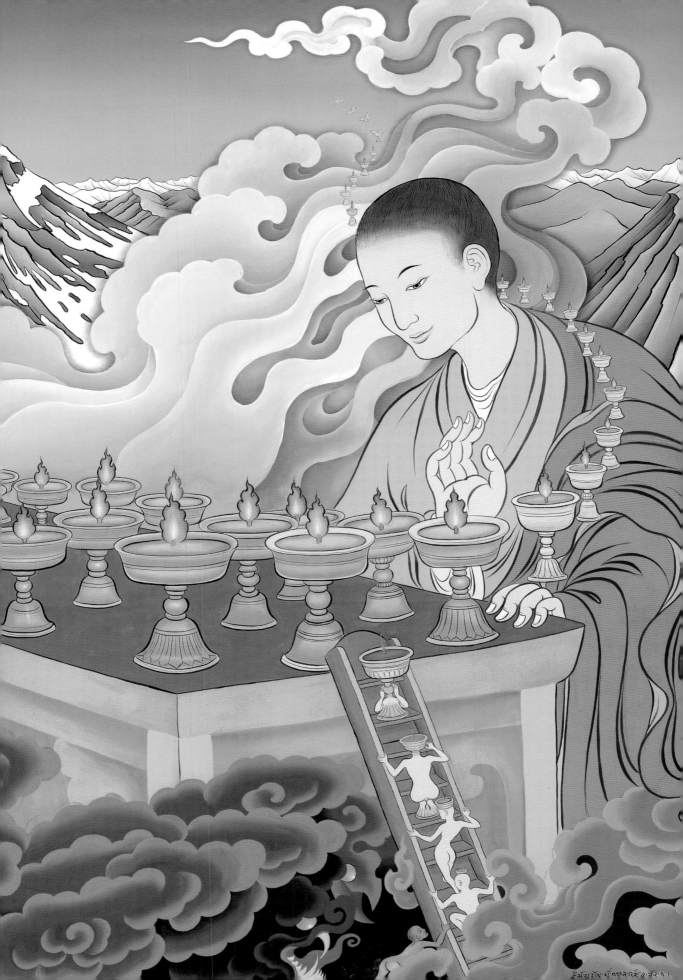

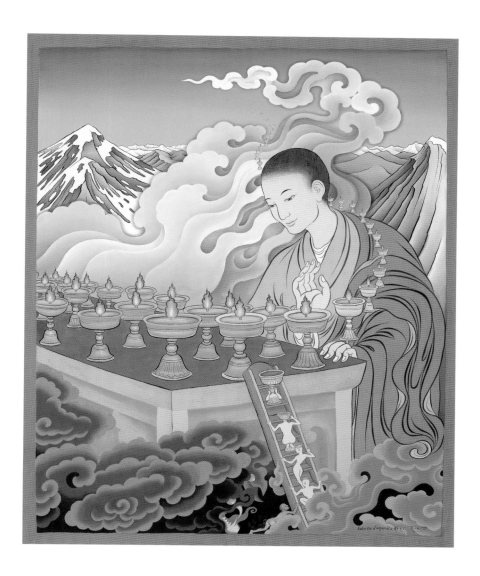

[Previous] *Story of the Northern Plain*, 2008; *Liberation*, 2008; [Facing] Detail

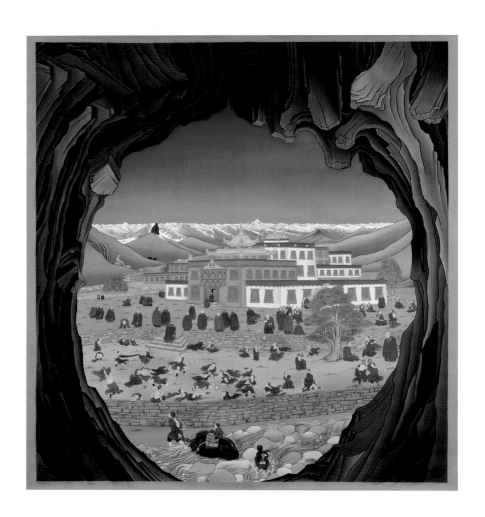

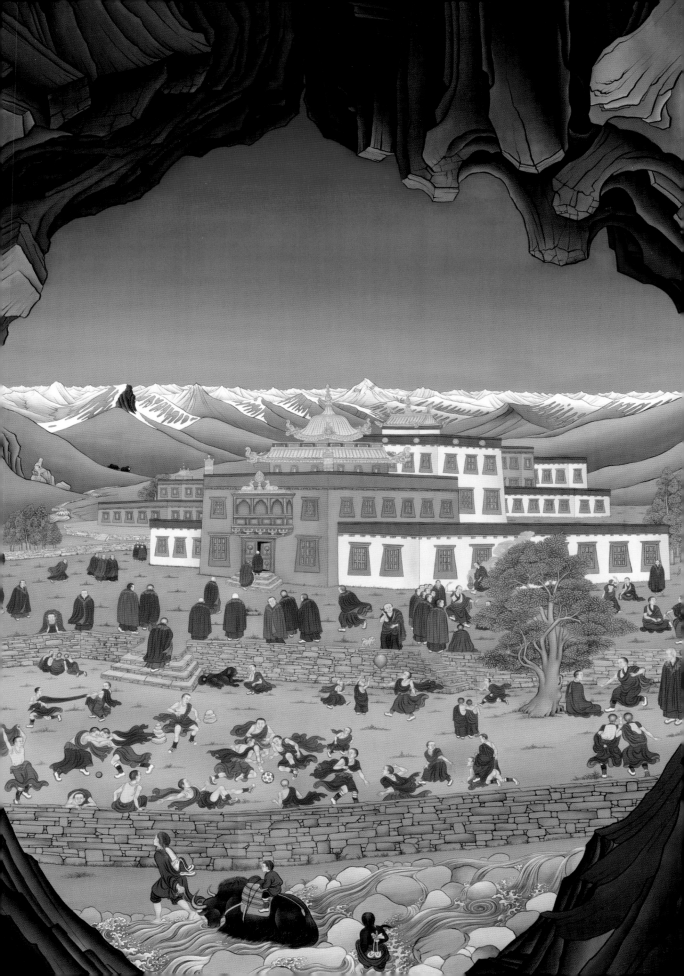

Tenzing Rigdol

བསྟན་འཛིན་རིག་གྲོལ།

bstan 'dzin rig grol

Tenzing Rigdol was born in Kathmandu, Nepal, in 1982. He studied art, philosophy and art history at the University of Colorado, graduating in 2005. Rigdol's training in traditional art forms began in 1997, when he learned Tibetan carpet design at the Tibetan Children's Village in Dharamsala, India. In 1998, he studied classical painting under Tsering Yankey. In 1999, Rigdol attended the School of Tibetan Thangka Painting in Nepal, where he studied under master painters Phenpo Tenzin Dhargay and Tenzin Gawa. Two years later, Rigdol learned Tibetan sand painting, butter sculpture and Buddhist doctrine at Shakhar Choten Monastery in Nepal. A student of Buddhist philosophy, he is also an accomplished poet. Rigdol and his family were granted political asylum in the US in 2002, and the artist now lives in New York.

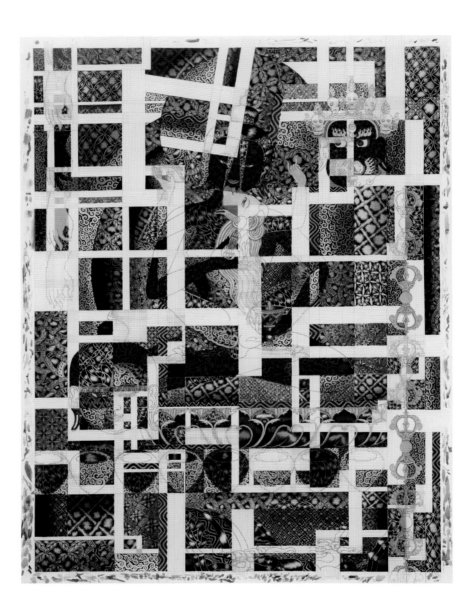

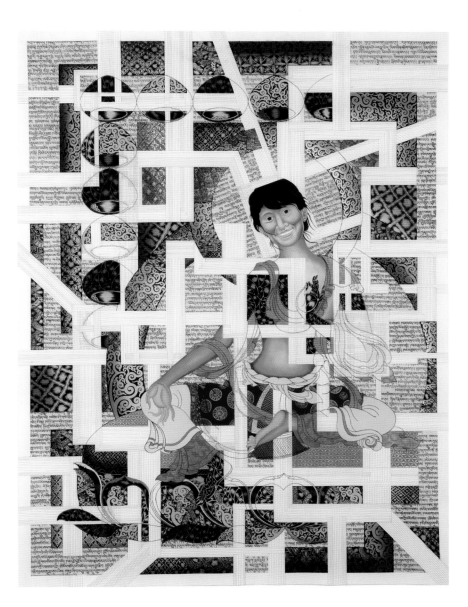

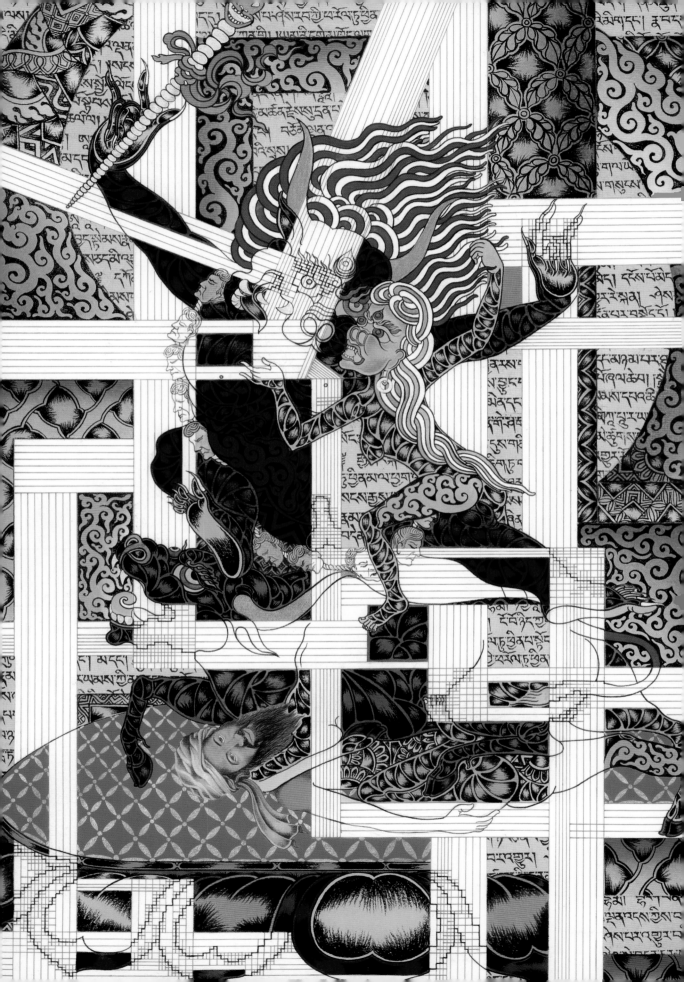

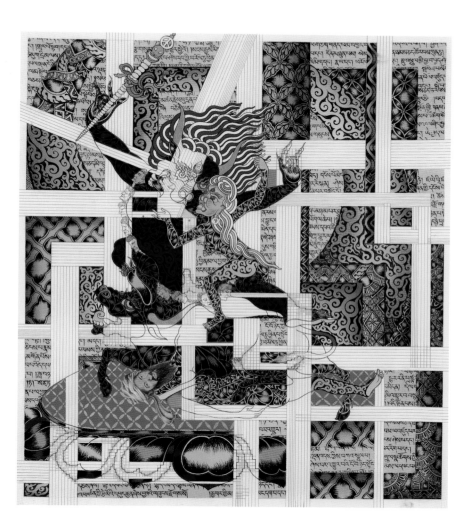

131

Pema Rinzin

padma rig 'dzin

Pema Rinzin was born in Tibet in 1966 and grew up in Dharamsala, India, where he studied with Kalsang Oshoe, Khepa Gonpo, Rigdzin Paljor and other master artists from 1979 to 1983. Rinzin subsequently taught Renaissance, Impressionist and Abstract Expressionist art, as well as cartoon drawing for eight years at the Tibetan Children's Village School in Dharamsala. From 1995 to 2004, he worked and taught at the Shoko-ji Cultural Research Institute in Nagano, Japan. From 2002 to 2005, he divided his time between Japan and Würzburg, Germany, where he was an artist-in-residence at the Brush & Color Studio. From November 2005 to October 2008, Rinzin was an artist-in-residence at the Rubin Museum of Art in New York. His paintings have been exhibited internationally and are held in public and private collections worldwide, most notably at the Shoko-ji Cultural Research Institute in Nagano, Japan, and the Rubin Museum of Art. Rinzin lives in New York.

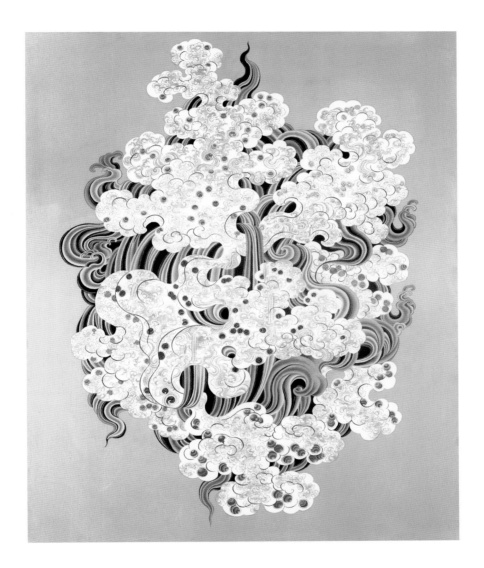

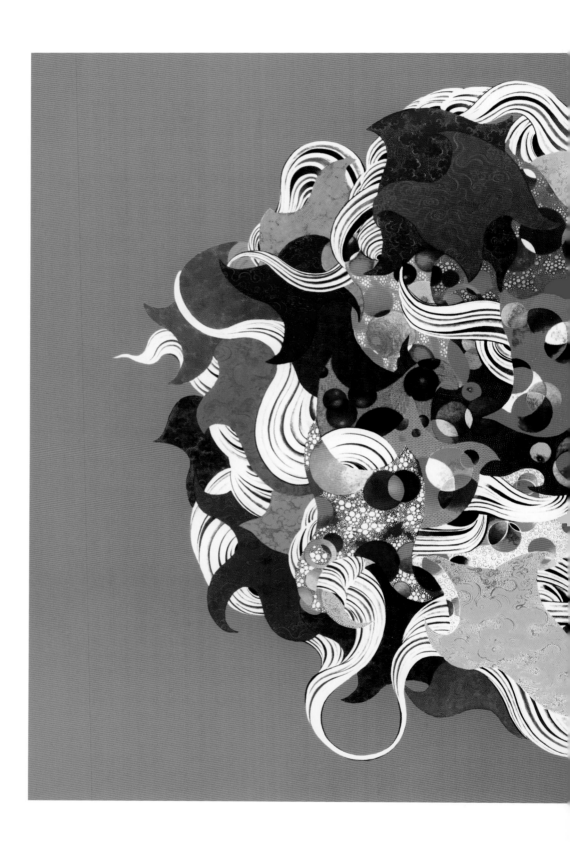

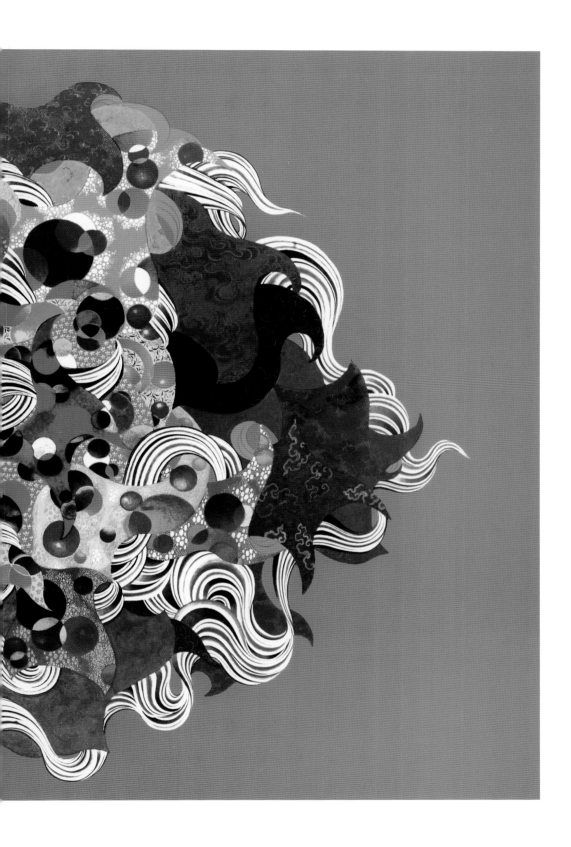

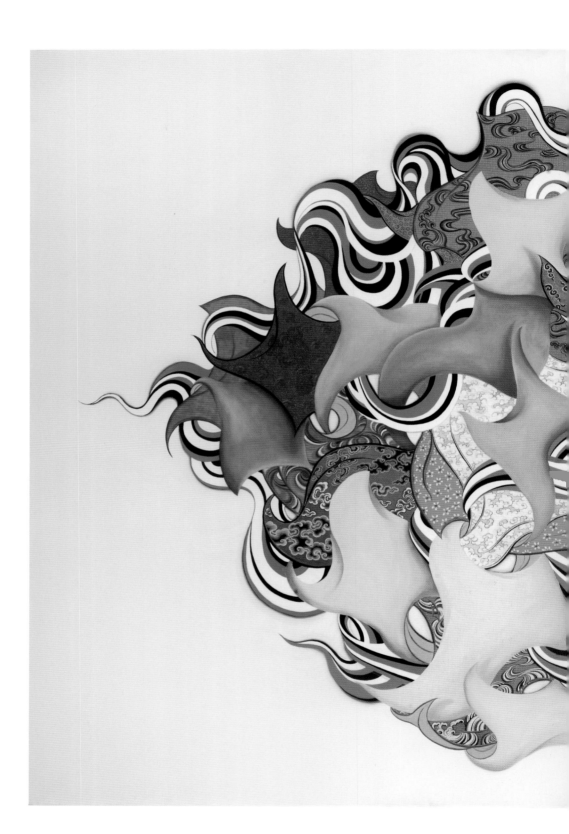

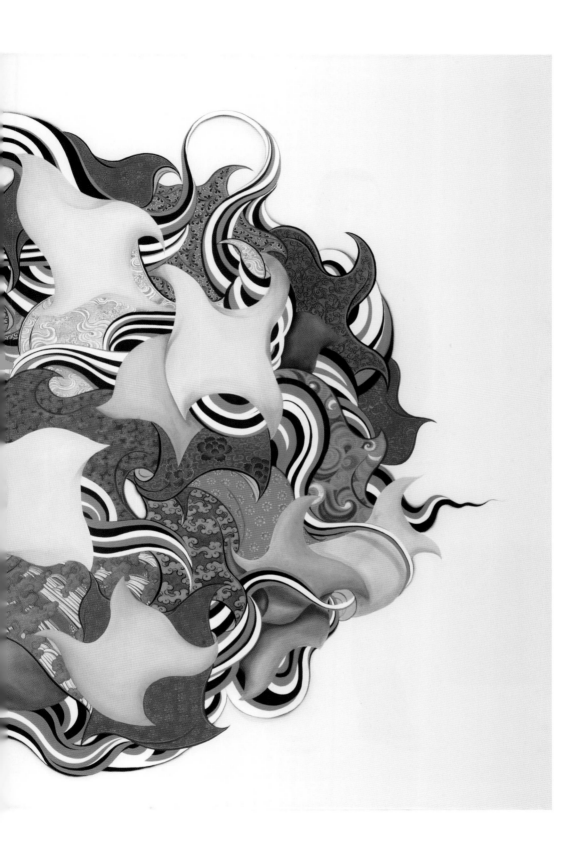

Tsherin Sherpa

ཚེ་རིང་ཤར་པ།

tshe ring shar pa

Tsherin Sherpa was born in Kathmandu, Nepal, in 1968. He began studying thangka painting at the age of 12 under the guidance of his father Urgen Dorje, a renowned thangka artist from Nyalam, Tibet. After six years of formal training, Sherpa went to Taiwan to study Mandarin Chinese and computer science for three years. He then returned to Nepal and resumed working with his father, painting both thangkas and wall murals. Sherpa immigrated to the US in 1998 and worked as an artist and as an instructor at the Healing Buddha Center in California. In the US, he pursued his own art, which actively questions the methods and rhetoric of preserving tradition in the modern world, as well as continuing to paint and to offer classes in thangka painting. He currently lives in Oakland.

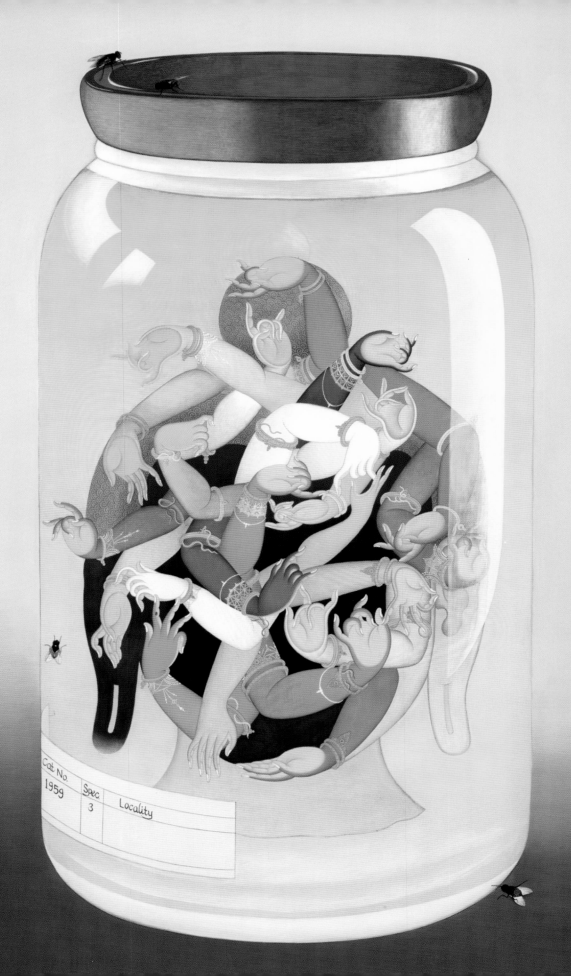

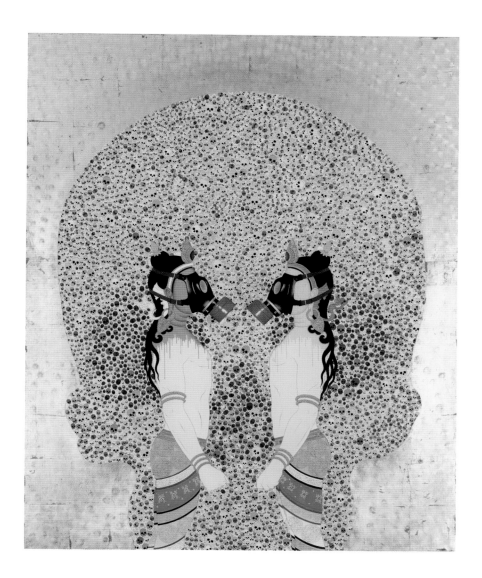

Untitled, 2010; [*Following*] *Butterfly Effect—The Chaos Theory*, 2008

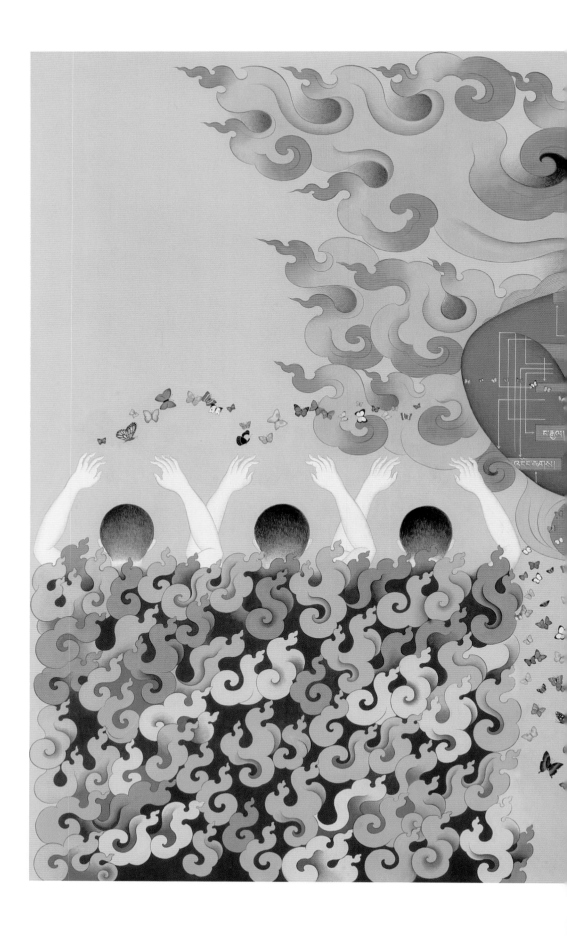

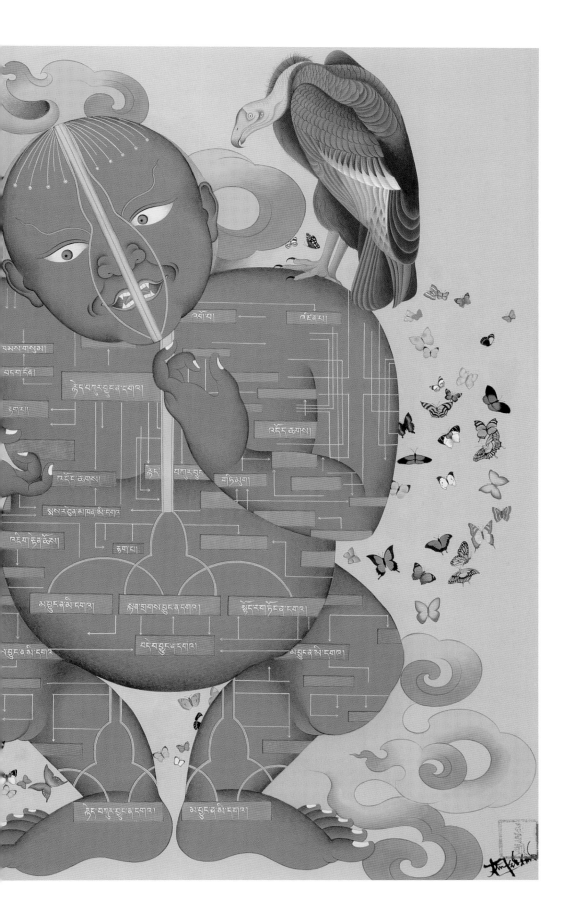

Penba Wangdu

པ་དབང་འདུས།

spen pa dbang 'dus

Penba Wangdu was born in Shigatse, Tibet, in 1969. He studied fine art at Tibet University, graduating in 1991. He taught at the Lhasa Normal School and began teaching at the Art Department of Tibet University in 1994. In 2000, he studied at the Central Academy of Fine Art in Beijing, where he specialized in mural painting. From 2002 to 2005 he studied for his MA in Tibetan fine arts at Tibet University; his thesis was entitled, "The Method of Painting: Tibetan Paintings During the 15th Century." Wangdu's work has been featured in gallery exhibitions in the US and the UK. He lives in Lhasa.

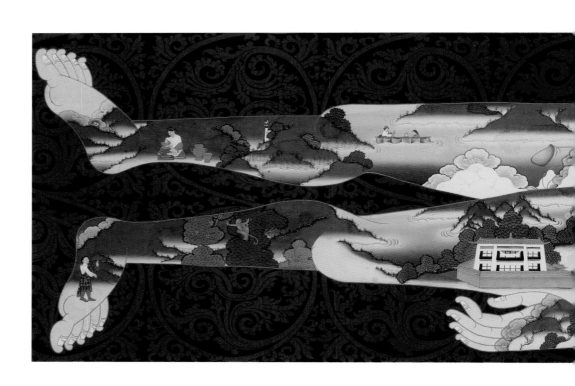

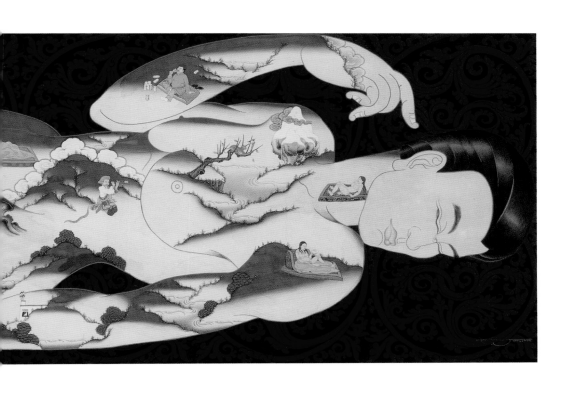

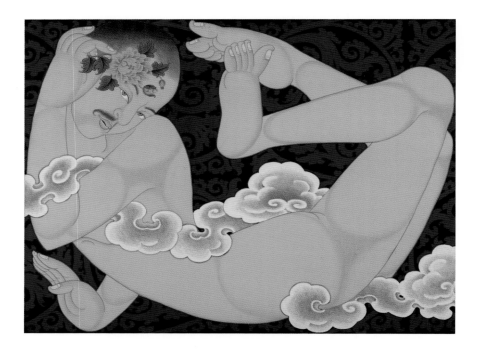

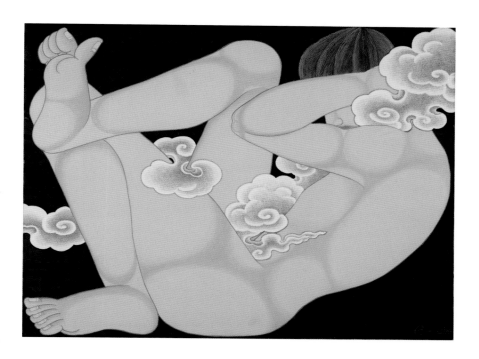

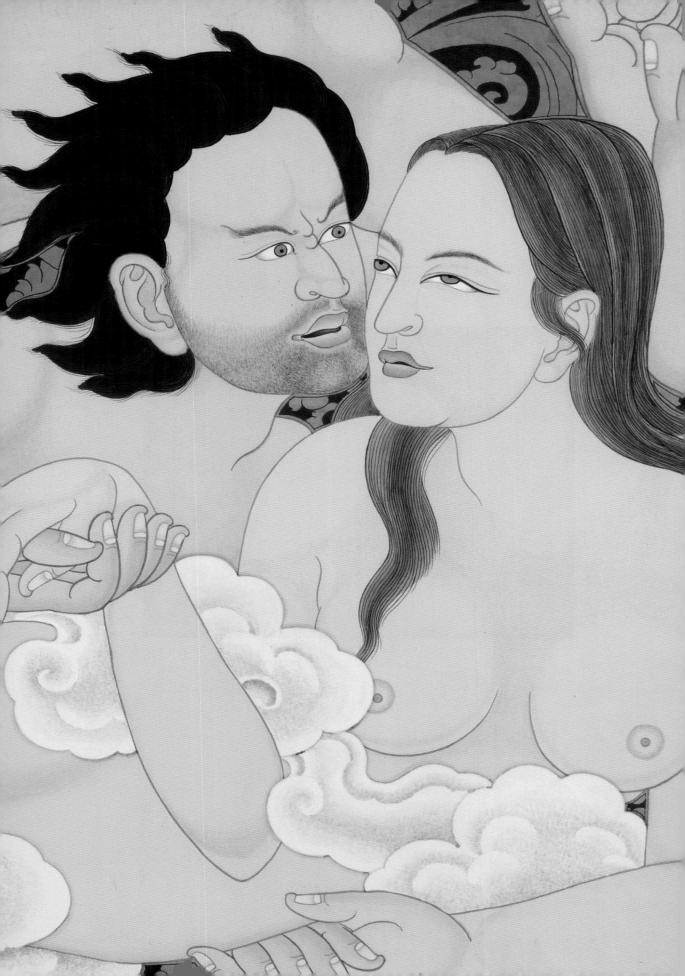

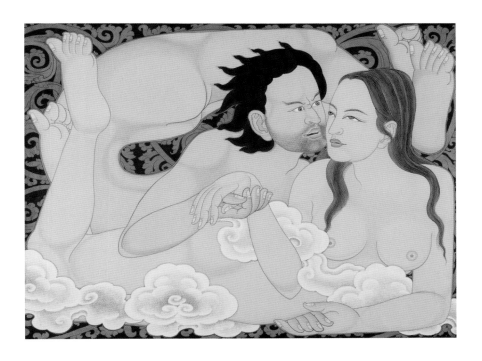

Early Days of the Gendun Chöpel Artists' Guild and the Lhasa Art Scene

An Interview with Paola Vanzo by Michael R. Sheehy

Sheehy *Could you describe how you became involved with the artists who would eventually establish Lhasa's first contemporary art gallery, the Gendun Chöpel Artists' Guild?*

Vanzo I moved to Lhasa in 1999, when I began working with the Trace Foundation to promote sustainable cultural development in Tibet. In the summer of 2000 we started researching possibilities to expand our projects in the cultural sector beyond the preservation work we had been doing. That summer, through Tenzin Gelek, one of my colleagues in New York, I met Tserang Dhundrup. That, for me, is when the story of the Gendun Chöpel Artists' Guild really begins. Tserang Dhundrup was working as a stage designer at the Song and Dance Troupe in Lhasa together with Tsering Dorje. They both expressed interest in traveling to Europe and the United States to exhibit their artwork. We thought we could play a role in creating an opportunity not just for them to show, but also for them to gain some exposure to international contemporary art.

Tenzin began looking for partners to sponsor a few Tibetan artists in New York for several months. He got in touch with the Snug Harbor Cultural Center, a large arts complex on Staten Island, which at the time had been running international artist residency programs for more than 14 years. They offered us a cottage that could comfortably house four people and gallery space for the artists to exhibit. Around the same time Tenzin also started talking to the Henry Street Settlement, a community center in lower Manhattan that was showing some underground artists in their residency program. Together with the Trace Foundation, these two organizations set up the International Cultural Collaboration Project, which paired the artists-in-residence at the Henry Street Settlement with the Tibetan artists-in-residence at Snug Harbor in order to foster a real exchange between these two groups. The artists at the Henry Street Settlement agreed to meet regularly with the Tibetans we would sponsor, and to take them to galleries and museums and to talk with them about contemporary art in New York. We at the Trace Foundation knew we wanted to sponsor Tserang Dhundrup and Tsering Dorje and, as Snug Harbor had two additional spaces, we decided to open those places up to a wider pool of applicants.

What were your early impressions of the art you saw in Tibet?

Tserang took me and another of my colleagues, Kim Morris, to meet some of the artists working in Lhasa. Many of them didn't have studios at that time, so we would meet at their homes. We'd share a cup of tea in their courtyards and talk about their work. Culturally these artists were very traditional, but a few—Gade and Benchung come to mind—were attempting something more original. It was quite a long way from what you

FIG 32

FIG 33

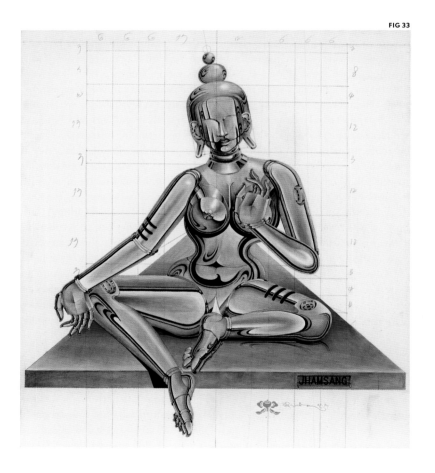

see today. I don't think you could have defined the art they were working on at that time as contemporary, but it definitely had some modern elements. Nyandak was working on some abstract painting. Gade was playing a lot with new kinds of imagery, but was still using traditional mineral colors with earth tones. **[FIG 32]**

There wasn't much of an art scene in those early days, and almost no one outside of Lhasa had heard of any of the artists working there. Of the artists we met, some had attended the Central Academy of Fine Arts in Beijing, others were enrolled in the Art Department at Tibet University. A few Lhasa artists were working as art teachers, or were simply self-employed. We ultimately received ten applications for the New York residency, and, at the end of 2001, art experts from Snug Harbor and Henry Street helped us select Gade and Benchung to join Tserang and Tsering Dorje.

How did the artists respond to their time in the United States?

The residency program at Snug Harbor lasted four months. None of them had ever been to the US, and I think they really had the time of their lives. They were a bit shocked, puzzled and overwhelmed by the art that they were seeing and the people they were meeting, but they really enjoyed the experience. The Asian Cultural Council, with whom we also collaborated, did a wonderful job of bringing other artists—performance artists in particular—to New York to meet and interact with the four Tibetan painters.

How did that experience then lead to the formation of the Gendun Chöpel Artists' Guild?

When the four artists and I were back in Lhasa together, I remember asking, "What was the strongest impression of your time in New York?" All four of them said that it was the studio buildings, especially in Brooklyn and Chelsea, full of artists, and the fact that different artists were working together and helping each other. Gade, Tserang and Benchung then had this idea to form an artist cooperative. It was the three of them who were really the forerunners of what later became the Gendun Chöpel Artists' Guild, along with Nyandak, another Lhasa-based artist, who would later play a pivotal role, together with Gade, in the daily management of the Guild.

During that period, there had been an increase in the number of tourists in Lhasa, and there was a lot of cheap art being sold. Though there were famous master artists and their students who were painting wonderful thangkas, in general the art products on the streets and in the small galleries were not very good. Most of the available works were stereotypical depictions of Tibetan life—paintings of yaks or portraits of nomads—as well as artwork meant to conjure up that Shangri-La mystique that brings many of the tourists to Tibet.

Gade, Tserang, Benchung and Nyandak wanted to do something different by bringing together a group of artists with a higher level of professionalism and quality to their artwork. Their aim was to keep the production and exhibition of contemporary Tibetan artists' work in their own hands and to create greater opportunities for self-expression. While Benchung decided to dedicate his time to his own art, Gade, Tserang and Nyandak joined forces with Jhamsang, Dedron, Zhungde, Wang Shimin, Bempa, Zhangping and Tsering Namgyal and formed the Guild in 2002. **[FIG 33]**

Could you describe how the Guild was organized and how it opened its gallery space?

By then I'd become very close to this incredible group of artists and regularly spent my evenings discussing with them the future of the Guild and the need for a charter that they could all agree on. They wanted to open a gallery as well—"a Tibetan window to the world" as they called it—to show their artwork. They had numerous questions: How will it work? What are the benefits? How much is it going to cost? Who has to pay for it? Everybody wanted to participate but hardly anybody wanted to share the expenses. Some artists had funds, but others didn't have any income, so that entire process took months. They put a lot of energy into drafting the charter and it is still in use today, with only a few modifications.

At the beginning of 2003, the Guild rented a space right in the center of the Barkhor area of old Lhasa. It used to be a Sichuanese restaurant and it took a lot of work to turn it into the beautiful space that opened its doors on September 1, 2003. By then Tsewang Tashi and Tenzin Jigme had also joined the group. The day of the opening was incredible. The gallery had a beautiful rooftop, and the artists gathered there and performed a ceremony in a cloud of incense.

I remember they had this little red door at the entrance of the building, and through it you could see one of Tsewang Tashi's big purple portraits. It was like a door into a different world. When they opened that gallery it provided a completely new and different way for Tibetan artists to see one another—and themselves—and to help each other. **[FIG 34]**

After the opening, how did the Guild grow and evolve?

At the outset, things worked very well at the gallery. The enthusiasm and the energy allowed the artists to manage things well, and everybody was very dedicated. But from the beginning it was clear that organizing the daily activities fell largely on the shoulders of Gade and Nyandak. The gallery was open all day, and the artists had different shifts to cover to ensure that one person was always there. But artists being artists—and especially Tibetan artists—many of them had only a vague sense of time and responsibilities. Eventually, they decided to appoint a gallery manager and to hire a young person to take care of the space. To cover the overhead, each one of them would contribute ten percent of the earnings from each painting sold. Every two weeks they would rotate the artworks to ensure that each artist could show their pieces on the best walls with the best light.

Were the artists able to sell their works? Who were some of their early patrons and collectors?

They slowly became more successful. I helped them in selling some of their artwork, and apart from myself, they found great support from Andrea Soros and Eric Colombel, the founder and vice president, respectively, of the Trace Foundation. I would often call Eric and tell him about the wonderful new pieces in the gallery but also about the difficulties some artists were having selling their work. And each time he graciously gave the funds to purchase the artwork, much of which is now hanging in our New York office. I also

FIG 34

FIG 35

FIG 36

introduced them to Ian Alsop, editor of Asianart.com and owner of a gallery in New Mexico dedicated to Tibetan art, and he started a long-term collaboration with them that continues to this day.

Thanks to the independent efforts of Gonkar Gyatso in London and the growing interest in his work outside of Tibet, the Guild started receiving more international attention, including an article in the *New York Times* in 2004. Several of the artists also started to travel and have exhibitions abroad. They were coming back with completely different views from the places that they visited. Their art began to reflect that and to move increasingly away from traditional Tibetan styles. Some, such as Gade, tried to depict their world: Lhasa in the mid-2000s was still uniquely Tibetan but increasingly exposed to global trends. Others, including Tserang, wanted to maintain their Tibetan cultural heritage while integrating their own experiences and perspectives. In their own ways, however, each of them was pulling together extremely diverse influences and showing how they could coexist, which is what life in Lhasa was like at the time.

The Guild became a meeting point for Lhasa artists and it continued to expand. Who joined later and how were they accepted?

Among the gallery's members were not only ethnic Tibetans, but also Han Chinese artists who had grown up in Tibetan areas. One of them, Zhungde, even speaks fluent Tibetan. It was an eclectic group that was growing together. As word about the Guild traveled fast beyond Lhasa, other Tibetan artists wanted to be a part of what was considered the city's best gallery. In 2004, Benchung and Ang Sang joined the group. Other new prospective members were introduced either through direct sponsorship or independently. The existing members would gather to look at the work of the applicants and vote on whether or not to accept the person. The group expanded slowly to its current number of 27. To help with expenses, a membership fee was established, which in 2003 was RMB 3,000 (USD 440). By the time I left in 2006 it had increased to RMB 5,000 ($733) and recently Gade told me it has reached RMB 30,000 ($4,395). **[FIGS 35–38]**

Several of the artists in the Guild were associated with the Art Department at Tibet University, either as students or instructors. What role did the school have in fostering artists during this formative period?

The Art Department at Tibet University has grown rapidly in the past few years, not only because there are more students interested in learning about traditional and modern art, but because there are good teachers at Tibet University, such as Penba Wangdu, Gade, Benchung and others. Eventually, some of their students became part of the Guild. Part of the school's campus moved to a new location on the outskirts of Lhasa in 2007, and it now has a much larger space. The government has also given a lot of support to the university in terms of building up its infrastructure.

What were the first modern elements you remember seeing in the artists' work when this scene first started around 2000?

FIG 37

FIG 38

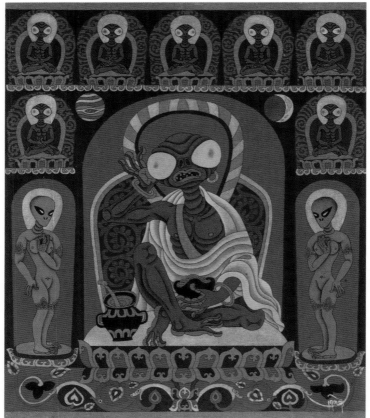

FIG 39

I am not an art critic or an expert, but I would say it was the imagery used in much of the work that was distinctly modern, particularly in Gade's paintings. He was painting characters and symbols from pop culture in a style derived from traditional religious art, which could be considered irreverent or sarcastic but which was actually meant earnestly. **[FIG 39]**

I remember in 2003 he was invited to go to an artist residency in Scotland for a month. One of the pieces that he painted there was one of his "Group Photo" paintings showing the head of the Buddha surrounded by a halo of different figures and signs—Ronald McDonald, Mickey Mouse, Red Guards and a Beijing opera singer, as well as traditional Tibetan symbols. One day he called me and said, "I'm not sure what I've been doing here. I don't think they really understand me." I said, "What happened?" and he replied, "I was showing some visitors my 'Group Photo' painting, which has the McDonald's logo in it, and they said, 'Oh good, so you're really against fast food. That's very impressive.'" And then he said, "I looked at them and in my broken English I simply said, 'Against? Oh no, I love hamburgers.'" It was really very funny because I also thought that he put those modern symbols in his work as a critique. But instead it was something that he wanted to incorporate, as it was part of his world.

Gade has a great sense of humor and is not afraid of expressing himself in his own unique way. Once, when I was looking at one of the large "Group Photo" canvases, I asked him about the Sherlock Holmes figures he had included: "Why on earth would you have Sherlock Holmes in your painting? What does this fictional character have to do with Tibet?" He smiled and told me that he had just watched one of the Sherlock Holmes movies a few nights before and really liked it. I always felt that his brush was the perfect bridge between past and future, tradition and modernity. When Gade paints I feel his mind goes back to his childhood days when he spent his free time drawing cartoons.

In preparing for "Tradition Transformed," the curators had many questions for the artists. We asked them: Who is the audience for your work? Who is this art attracting? In your view, was there an immediate magnetism toward or interest in the Gendun Chöpel Artists' Guild in Lhasa? Since it is located downtown on the main Barkhor circuit around the Jokhang temple, who was viewing the gallery on a daily basis, and what were the reactions of Tibetans who were visiting?

Gaining local acceptance was a very slow process. A lot of the local Tibetans who were circumambulating the Jokhang temple would see that the Guild was right there, and some of them were trying to understand what was going on. There was a mixed reaction. A few days after the opening I was standing just outside the entrance and this old man with his sheep was passing by. A familiar figure in the Barkhor in those days, he went in and took his time observing the paintings on the ground floor. I'll never forget his face when he came out, and I still can't figure out if it was a smirk of disgust or a savvy smile.

At first, the Guild was primarily orientated toward the tourist industry. People from Singapore, Hong Kong, Taiwan, as well as from Europe and North America bought the work. Of course, the artists were hoping that they could show their art to foreigners, so anybody who was associated with one of the international organizations in Lhasa and had some interest in art was invited there.

FIG 40

The artists then slowly came to the decision that they wanted to do something for the local community as well. In 2004, they established a scholarship fund to support younger artists. In the beginning, it was just art supplies and canvas, but then they decided that they wanted to support their schooling as well. They appended a clause to the original charter by which a percentage of the gallery's sales would go into this common fund in order to offer scholarships. Many of the artists are not wealthy, but they understand the importance of fostering their own culture.

Did the Guild encounter any major problems?

The majority of the Guild members were not there just to become famous or sell their works to foreigners. There were some, however, who were more interested in painting whatever would sell. For example, if, on a Monday, somebody came in and bought a portrait of the Buddha, the next day one of them would bring in a very similar new painting. Also, there were cases of some artists becoming more famous than the others, such as Gade, and people trying to imitate them.

But almost from the beginning, it was decided that each new painting that was brought to the gallery had to be voted on by all the Guild's artists to decide whether it was worth being shown. I think that was a good decision because it maintained the gallery's quality and kept members from piggybacking on the efforts of another artist who had more creative ideas, or who was simply working harder.

Who are the women artists involved in the Guild and the Lhasa art scene?

I think that Dedron is definitely the most interesting female Tibetan artist currently working in Lhasa. She's not the only one though, but the others have a more traditional imprint in their work, which doesn't match the aim of the Guild. Dedron's experience as a teacher working with children is really what makes her unique. She has such an innocence about her as well, and you can really see her love for animals in her paintings. I remember at one point, she was the only person in Lhasa who had this little kind of dog. It was the most expensive dog you could possibly imagine, and it was so small, like a squirrel, but she loved it passionately. She also had big dogs at home, along with birds, and other kinds of animals and flowers. She has all of these creatures around her, and that's what she paints.

What different influences—in terms of media, style or technique—did the artists involved in the gallery show in their work?

An interesting aspect of the Guild was that they were inviting people from around the world to give talks on different topics. This was very influential to the artists' work. Nyandak was particularly active in identifying artists who could come and speak. To date there have been a total of 11 or 12 such lectures or workshops. Lois Conner, a New York-based photographer spoke, and while she was there she took a beautiful portrait of the artists in front of the Potala Palace. Brad Brown, another New York artist, gave a very interesting talk in 2006 about the use of different paper and materials. Several

famous Chinese artists, including Qiu Zhijie, as well as the art critic Li Xianting, also came to speak. **[FIG 40]**

Because of the exposure to international artists visiting Lhasa, but also thanks to trips to Hong Kong, Europe and the US, where they were able to visit museums and galleries, Gade, Nortse, Nyandak and Benchung—to name a few—began using new materials and different media. Nortse painted some wonderful fish on tobacco leaves, and Benchung started to experiment with video and sculpture. It was around 2006 that Gade started looking into traditional Tibetan paper. He began creating *pecha*-sized paintings on wax paper, which is typically used for traditional Tibetan religious texts. He wanted to depict 108 images—a meaningful number in Buddhism—in a book. He was selling them off fairly quickly and he was really enjoying the medium, so they became bigger and bigger and longer and longer. For a couple of years, he stopped working on canvas entirely, and is now using all different kinds of media from photographs to an ice sculpture that he slowly melted in the Kyichu River. They are all following their own paths, and the group is becoming increasingly eclectic.

What has happened to the Guild in recent years?

I left Lhasa in 2006, and two years later the gallery moved from its original location. It is now housed in a beautiful building alongside the Kyichu River. There are still 27 artists in the Guild, and I trust that they will continue to grow and bring not just a Tibetan perspective but their own individual expressions to the rest of the world. In just ten years, contemporary Tibetan art has emerged from almost nothing to its current global status. I can't wait to see what the next ten will hold.

Paola Vanzo is the director of communications and operations for the Trace Foundation, an international nongovernmental organization based in New York that supports development and cultural continuity on the Tibetan plateau. From 1999 to 2006, Vanzo lived in Lhasa, where she managed the Trace Foundation's field office for the Tibet Autonomous Region. In this capacity she met many Lhasa-based artists, and in 2001, she facilitated the placement of four painters—Gade, Tserang Dhundrup, Tsering Dorje and Benchung—in an artist residency at the Snug Harbor Cultural Center in New York.

Acknowledgments

RACHEL WEINGEIST

There are many people who deserve to be thanked for their assistance during the various stages of this exhibition's development, beginning with Shelley and Donald Rubin, whose significant private collection and profound dedication to Tibetan art and culture inspired "Tradition Transformed."

I first became familiar with contemporary Tibetan art in 2006, through my interactions with Ian Alsop of Peaceful Wind Gallery, Fabio Rossi of Rossi & Rossi and Edward Wilkinson of EW Art—connoisseurs, intrepid collectors and dealers who bring paintings back from Lhasa and Kathmandu. I thank them for their willingness to teach me and for their help in formulating the idea for this exhibition. I am so fortunate to work in close proximity to E. Gene Smith, the founder and senior scholar at the Tibetan Buddhist Resource Center, who has extended his endless patience in the face of my never-ending inquiries. His staff members, including Jeff Wallman, Michael Sheehy and Lobsang Shastri, also graciously shared their passion and expertise with me. My generous colleagues Alex Gardner and Bruce Payne at the Shelley & Donald Rubin Foundation offered their assistance at every turn, as this exhibition moved from idea to reality.

This catalog and exhibition never would have made a single deadline without the willing support of all of the staff at Shelley and Donald Rubin's private office, in particular Heidi Albee, Mary Britt, Deborah Fisher, Anna Gonick, Elise Roedenbeck and Jared Spafford.

Thank you also to Paola Vanzo from the Trace Foundation for sharing her extraordinary perspective on living in Lhasa during the time when the seminal Gendun Chöpel Artists' Guild was established and its gallery space opened in 2003.

Through many of the friends mentioned above, I have been fortunate to meet or communicate directly with most of the nine artists in "Tradition Transformed." Gonkar Gyatso, Losang Gyatso, Tenzing Rigdol, Pema Rinzin and Tsherin Sherpa have all taken time to educate me in person about their artistic practice and inspiration. Sienna Craig, a Dartmouth University anthropology professor, introduced me to Tenzin Norbu, who traveled from the Dolpo region of Nepal to work in retreat at the Vermont Studio Center. He found time on his visit to New York City to teach my daughter Elsa's class from the Earth School at the Rubin Museum of Art (RMA).

I would like to express deep appreciation for the work of all my colleagues at the RMA who have each contributed significantly to the realization of "Tradition Transformed," especially assistant curator Rebecca Bloom, who worked closely with me to create this exhibition. Thank you also to chief curator Martin Brauen and the rest of the staff, including Helen Abbott, Vincent Baker, Kavie Barnes, Michelle Bennett, Amy Bzdak, Marilena Christodoulou, Alisha Ferrin, Tracey Friedman, Cate Griffin, Zachary Harper,

Jenny Hung, Jonathan Kuhr, Tim McHenry, John Monaco, Shane Murray, Anne-Marie Nolin, Andrea Pemberton, Alanna Schindewolf, Brian Schneider, Patrick Sears, Marcos Stafne and Taline Toutounjian.

What a breath of fresh air Hanae Ko, Joon Mo Kang, Michael Lacoy, Elaine W. Ng and the outstanding staff of *ArtAsiaPacific* are to work with. HG Masters, *ArtAsiaPacific* editor-at-large and contributor to this publication, thank you for your diligence and for bringing levity to the stressful process of creating a book. Thanks to Peter J. Ahlberg, publication designer—the book is beautiful!

Huge thanks to Nicholas Pavlik and Joe Dezzi at Conservation Framing, as well as to Steven Beyer from Beyer Art, for the quiet precision they continually provide.

Of course, the exhibition and catalog would have been impossible without the generosity and cooperation of all of the lenders and donors. They are listed separately, but I would like to take this opportunity to personally thank them for their support and enthusiasm. May the show mark the beginning of more international exposure for all contemporary Tibetan artists!

Appendix

FIG 18
Dolma, Sonam
Red Carpet, 2010
Wood, red and white pigments, plaster
55-inch diameter (140 cm)
Courtesy the artist

FIG 19
Dolma, Sonam
My Father's Death, 2010
49 monk robes, nine *tsa tsas*
100 x 100 x 70 cm
Courtesy the artist

FIG 20
Norbu, Tashi
Touching the Earth, 2008
Pigments, acrylic, Indian ink
39.4 x 39.4 inches (100 x 100 cm)
Courtesy the artist

FIG 21
Weinreb, Palden
Bow, 2008
Graphite and silverpoint on paper
25.9 x 18.5 inches (65 x 47 cm)
Collection of Tara Jackson-Shaw.
Courtesy Rossi & Rossi, London

FIG 22
Brauen, Tashi
Interieur, 2010
Industrial awning, furniture, light, sound
Dimensions variable
Installation view at Raumsprung Interlokal,
Zürich, 2009
Courtesy the artist

FIG 23
Gyatso, Gonkar
Angel, 2007
Stickers and pencil on treated paper
60 x 48 inches (152 1/2 x 122 cm)
Collection of Queensland Art Gallery,
Brisbane. Courtesy Rossi & Rossi, London

FIG 24
Sherpa, Tsherin
Derivative 1, 2009
Gouache, acrylic and gold on paper
15.7 x 11.8 inches (40 x 30 cm)
Collection of Shelley and Donald Rubin

FIG 25
Sherpa, Tsherin
Things That POP In My Mind, 2009
Gouache, acrylic and gold leaf on paper
40 x 30 inches (101.6 x 76.2 cm)
Private collection, New York.
Courtesy Rossi & Rossi, London

FIG 26
Rigdol, Tenzing
Obama Mandala, 2008
Acrylic on canvas
43 x 43 inches (109.2 x 109.2 cm)
Private collection, Milan.
Courtesy Rossi & Rossi, London

FIG 27
Rigdol, Tenzing
Buddha-Ahh! Deconstruction Experienced,
2007
Oil on canvas
68.9 x 47.2 inches (175 x 120 cm)
Collection Peggy Scott and David
Teplitzky. Courtesy Rossi & Rossi,
London

FIG 28
Dedron
Mona Lisa With Pet, 2009
Mineral pigment on canvas
51 x 38 inches (130 x 97 cm)
Courtesy the artist and Rossi & Rossi,
London

FIGS 29, 30
Lamdark, Kesang
Pink Himalayan Boulder, 2008
Tibetan boulder, melted pink plastic
Site-specific installation at
ShContemporary, Shanghai, 2008
Courtesy the artist and Rossi & Rossi,
London

FIG 31
Lamdark, Kesang
Pink Tara, 2008
Neon light, plastic and chicken wire
56.3 x 22.4 x 19.7 inches
(143 x 57 x 50 cm)
Courtesy the artist and Rossi & Rossi,
London

FIG 32
Gade
Pastoral Songs, 1992
Mineral pigments on canvas
38.2 x 57.5 inches (97 x 146 cm)
Collection of Himalaia Hotels, S.L.U.

FIG 33
Jhamsang
Tara, 2008
Acrylic on canvas
45 x 40 inches (114.3 x 101.6 cm)
Collection of Shelley and Donald Rubin

FIG 34
Tashi, Tsewang
Untitled No. 4, 2006
Oil on canvas
53 x 53 inches (134.6 x 134.6 cm)
Collection of Shelley and Donald Rubin

FIG 35
Ang Sang
Buddha, 2005
Mixed media on canvas
39 x 39 inches (99.1 x 99.1 cm)
Collection of Shelley and Donald Rubin

FIG 36
Ang Sang
Nomadic Girls, 2006
Acrylic and mineral pigments on canvas
35.4 x 35.4 inches (90 x 90 cm)
Collection of Himalaia Hotels, S.L.U.

FIG 37
Dhandrup, Tserang
Walking Monk, 2003
Oil on canvas
26 x 32 inches (66 x 81.3 cm)
Collection of Shelley and Donald Rubin

FIG 38
Shelka
Two Khampas, 2004
Ink and watercolor on paper
52 x 26.5 inches (132.1 x 67.3 cm)
Collection of Shelley and Donald Rubin

FIG 39
Gade
ET-Milarepa, 2008
Mixed media on canvas
24 x 19.5 inches (61 x 49.5 cm)
Collection of Shelley and Donald Rubin

FIG 40
Conner, Lois
Untitled, 2005
Pigment ink print on Hahnemühle paper
23 x 60 inches (58.4 x 152.4 cm)
Collection of Shelley and Donald Rubin

Artists

DEDRON

Portrait of Dedron at her studio in Lhasa, Tibet, 2010. Courtesy the artist.

Grandparents–Son, 2010
Mineral pigments on canvas
86.6 x 31.5 inches (220 x 80 cm)
Courtesy the artist

We are the Nearest to the Sun, 2009
Mineral pigments on canvas
65.5 x 33 inches (166.4 x 83.8 cm)
Collection of Shelley and Donald Rubin

GONKAR GYATSO

Portrait of Gonkar Gyatso in his studio in New York, USA, 2010. Photograph by Mark Mahaney for *ArtAsiaPacific*.

LA Confidential, 2007
Pencil and stickers on art paper
38 x 28 inches (96.5 x 71.1 cm)
Private collection, Pasadena

Tibetan Idol 10, 2006
Stickers and ink on treated paper
18.5 x 14 inches (47 x 35.6 cm)
Private collection, New York

Tibetan Idol 15, 2006
Stickers and ink on treated paper
27.5 x 27.5 inches (69.9 x 69.9 cm)
Private collection, New York

My Identity 1, 2003
Limited edition digital photograph
22.3 x 27.8 inches (56.6 x 70.6 cm)
Collection of Shelley and Donald Rubin

My Identity 2, 2003
Limited edition digital photograph
22.3 x 27.8 inches (56.6 x 70.6 cm)
Collection of Shelley and Donald Rubin

My Identity 3, 2003
Limited edition digital photograph
22.3 x 27.8 inches (56.6 x 70.6 cm)
Collection of Shelley and Donald Rubin

My Identity 4, 2003
Limited edition digital photograph
22.3 x 27.8 inches (56.6 x 70.6 cm)
Collection of Shelley and Donald Rubin

LOSANG GYATSO

Portrait of Losang Gyatso with his work in New York, USA, 2010. Photograph by Mark Mahaney for *ArtAsiaPacific*.

Clear Light Tara, 2009
Limited edition photographic print on paper
36 x 30 inches (91.4 x 76.2 cm)
Courtesy the artist

Green Zone of Amoghasiddhi, 2007
Light-jet print
Edition 4 of 5
18 x 21 inches (45.7 x 53.3 cm)
Collection of Shelley and Donald Rubin

KESANG LAMDARK

Portrait of Kesang Lamdark in his studio in Zürich, Switzerland, 2010. Photograph by Elisabeth Real for *ArtAsiaPacific*.

Dance of Death: Chitipati, 2007
Print on fine art paper
35.5 x 47 inches (90.1 x 119.4 cm)
Collection of Elaine W. Ng and Fabio Rossi

Temple Dancer, 2007
Print on fine art paper
35.5 x 47 inches (90.1 x 119.4 cm)
Courtesy the artist and Rossi & Rossi, London

Arhat, 2007
Print on fine art paper
35.5 x 47 inches (90.1 x 119.4 cm)
Courtesy artist and Rossi & Rossi, London

Garuda, 2007
Print on fine art paper
35.5 x 47 inches (90.1 x 119.4 cm)
Collection of Elaine W. Ng and Fabio Rossi

O Mandala Tantric, 2009
Plexiglass, LED light and wood
47.2 x 3.9 inches (119.9 x 9.9 cm)
Courtesy the artist

Dance of Death: Chitipati, 2007
Beer can
7.5 x 4 inches (19 x 10.2 cm)
Collection of Elaine W. Ng and Fabio Rossi

Can in Blue Hand, 2007
Found objects
9 x 9 x 8 inches (22.9 x 22. 9 x 20.3 cm)
Collection of Shelley and Donald Rubin

TENZIN NORBU

Portrait of Tenzin Norbu during his stay in Kathmandu, Nepal, in 2010. Photograph by Tom Van Cakenberghe for *ArtAsiaPacific*.

Story of the Northern Plain, 2008
Stone ground pigments on cloth
31 x 46 inches (78.7 x 116.8 cm)
Collection of Shelley and Donald Rubin

Liberation, 2008
Stone ground pigments on cloth
28 x 20 inches (71.1 x 50.8 cm)
Collection of Shelley and Donald Rubin

Speech & Meditation, 2009
Stone ground pigments on cloth
53 x 48 inches (134.6 x 121.9 cm)
Courtesy the artist

TENZING RIGDOL

Portrait of Tenzing Rigdol with his work in New York, USA, 2010. Photograph by Mark Mahaney for *ArtAsiaPacific*.

Fusion Tantra, 2008
Ink, watercolor and pastel on paper
48 x 36 inches (121.9 x 91.4 cm)
Collection of Shelley and Donald Rubin

Updating Green Tara, 2010
Watercolor pastel and scripture on paper
48 x 37 inches (121.9 x 94 cm)
Courtesy the artist

Updating Yamantaka, 2010
Pastel and scripture on paper
22 x 19.5 inches (55.9 x 49.5 cm)
Courtesy the artist

PEMA RINZIN

Portrait of Pema Rinzin in his studio in New York, USA, 2010. Photograph by Mark Mahaney for *ArtAsiaPacific*.

Water, 1, 2009
Ground mineral pigments, acrylic, dye, watercolor and gold on cloth
61 x 41 inches (154.9 x 104.1 cm)
Courtesy the artist

Peace and Energy, 1, 2009
Ground mineral pigments and gold
on cloth
41 x 61 inches (154.9 x 104.1 cm)
Courtesy the artist

Peace and Energy, 2, 2009
Ground mineral pigments and gold
on cloth
41 x 61 inches (154.9 x 104.1 cm)
Courtesy the artist

TSHERIN SHERPA

Portrait of Tsherin Sherpa with his work
in New York, USA, 2010. Photograph by
Mark Mahaney for *ArtAsiaPacific*.

Preservation Project #1, 2009
Gouache, acrylic and gold on paper
43 x 34 inches (109.2 x 86.4 cm)
Collection of Shelley and Donald Rubin

Untitled, 2010
Gouache, acrylic and gold leaf on
museum board
37 x 30 inches (94 x 76.2 cm)
Courtesy the artist

Butterfly Effect—The Chaos Theory, 2008
Gouache on cloth
21.5 x 29.2 inches (54.6 x 74.2 cm)
Collection of Shelley and Donald Rubin

PENBA WANGDU

Portrait of Penba Wangdu in his studio in
Lhasa, Tibet. Courtesy the artist.

Links of Origination, 2007
Stone ground pigments on cloth
27 x 78 inches (68.6 x 198.1 cm)
Collection of Shelley and Donald Rubin

The Five Poisons #4, Jealousy, 2005
Stone ground pigments on cloth
23.5 x 31.5 inches (59.7 x 80 cm)
Collection of Shelley and Donald Rubin

The Five Poisons #5, Ignorance, 2005
Stone ground pigments on cloth
23.5 x 31.5 inches (59.7 x 80 cm)
Collection of Shelley and Donald Rubin

The Five Poisons #1, Desire, 2005
Stone ground pigments on cloth
23.6 x 31.3 inches (60 x 79.5 cm)
Collection of Shelley and Donald Rubin

Works Cited

TRANSFORMING A TRADITION:
TIBETAN ARTISTS ON THE DIALECT OF
SANCTITY AND MODERNITY

Chöpel, Gendün. *In the Forest of Faded
Wisdom: 104 Poems by Gendün Chöpel,
A Bilingual Edition,* edited by Donald S.
Lopez Jr. Chicago: University of Chicago
Press, 2009.

Dge 'dun chos 'phel. Gsung *'bum*. Lha sa:
Bod ljongs bod yig dpe rnying dpe skrun
khang, 1990.

Gyatso, Janet. "Image as Presence." In
*From the Sacred Realm: Treasures of Tibetan
Art from the Newark Museum*, edited by
Valrae Reynolds, 171–176. New York:
Prestel, 1999.

Harris, Clare. *In the Image of Tibet: Tibetan
Painting after 1959*. London: Reaktion
Books, 1999.

————. "The Buddha Goes Global:
Some Thoughts Towards a Transnational
Art History." In *Art History* 29, no. 4
(2006): 712.

Holmes-Tagchungdarpa, Amy.
"Re-imagi(ni)ng the Buddha: The
Multiplicity of Authenticities in
Contemporary Tibetan Art." Asia
Art Archive. http://www.aaa.org.hk/
newsletter_detail.aspx?newsletter_id=546.

Ivy, Marilyn. "Modernity." In *Critical
Terms for the Study of Buddhism*, edited by
Donald S. Lopez Jr., 311–331. Chicago:
University of Chicago Press, 2005.

Kvaerne, Per. "The Ideological Impact on
Tibetan Art." In *Resistance and Reform in
Tibet*, edited by Shirin Akiner and Robert
Barnett. Bloomington: Indiana University
Press, 1994.

Lopez, Donald S. Jr. *Prisoners of Shangri-La:
Tibetan Buddhism and the West*. Chicago:
University of Chicago Press, 1998.

Stoddard, Heather. "The Development in
Perceptions of Tibetan Art: From Golden
Idols to Ultimate Reality." In *Imagining
Tibet: Perceptions, Projections, and Fantasies*,
edited by Thierry Dodin and Heinz Räther.
Somerville: Wisdom Publications, 2001.

Teiser, Stephen F. *Reinventing the Wheel:
Paintings of Rebirth in Medieval Buddhist
Temples*. Seattle: University of Washington
Press, 2006.

Wylie, Turrell V. "Etymology of Tibetan:
Bla ma." In *Central Asiatic Journal*, 21
(1977): 148.

BLURRING BOUNDARIES:
CONTEMPORARY ART FROM TIBET
AND THE DIASPORA

Brauen, Martin. *Dreamworld Tibet: Western
Illusions*. Trumbull: Weatherhill, 2004.

Dagyab, Loden Sherap. "On the
Significance of Tibetan Buddhist Art and
Iconography." In *Dating Tibetan Art*,
edited by Ingrid Kreide-Damani, 5–14.
Wiesbaden: L. Reichert Verlag, 2003.

Dagyab, Loden Sherap. *Tibetan Religious
Art*. Wiesbaden: Harrassowitz Verlag, 1977.

Dodin, Thierry, and Heinz Räther. *Mythos
Tibet: Wahrnehmungen, Projektionen,
Phantasien*. Ostfildern: DuMont, 1997.

Gömpojab. "Regulations and Rules on
Making Statues and Images of the Buddha."
In *The Buddhist Canon of Iconometry*,
65–69. Ulm: Fabri Verlag, 2006.

Gyatso, Gonkar. "No Man's Land: Real
and Imaginary Tibet: The Experience of
an Exiled Tibetan Artist." In *Tibet Journal*,
Vol. XXVIII, Spring/Summer (2003):
147–160.

Gyatso, Janet. "Image as Presence." In
*From the Sacred Realm: Treasures of Tibetan
Art from the Newark Museum*, edited by
Valrae Reynolds, 171–176. New York:
Prestel, 1999.

Harris, Clare. *In the Image of Tibet: Tibetan
Painting after 1959*. London: Reaktion
Books, 1999.

Jackson, David and Janice Jackson. *Tibetan Thangka Painting – Methods & Materials.* Chicago: Serindia Publications, 1986.

Kreide-Damani, Ingrid. *Dating Tibetan Art: Essays on the Possibilities and Impossibilities of Chronology from Lempertz Symposium,* Cologne. Wiesbaden: L. Reichert Verlag, 2003.

Lopez, Donald S., Jr. *Prisoners of Shangri-La: Tibetan Buddhism and the West.* Chicago: University of Chicago Press, 1998.

———. *The Madman's Middle Way: Reflections on Reality of the Tibetan Monk Gendün Chöpel.* Chicago: University of Chicago Press, 2006.

Tashi, Tsewang. "*Art In Process.*" Thesis of Tsewang Tashi on Contemporary Tibetan Art presented to the Department of Colour, Oslo National Academy of Arts for the Master of Arts Degree. Oslo 2001. (unpublished)

Further Readings

Abe, Stanley. "Inside the Wonder House: Buddhist Art and the West." In *Curators of the Buddha: The Study of Buddhism Under Colonialism,* edited by Donald S. Lopez Jr. Chicago: The University of Chicago Press, 1995.

Alsop, Ian. "Contemporary Art in Lhasa." In *Orientations* 38, no. 5 (2007).

Alsop, Ian, and Clare Harris. *Visions from Tibet: A Brief Survey of Contemporary Paintings.* London: Anna Maria Rossi and Fabio Rossi Publications, 2005.

Baas, Jacquelynn. *Smile of the Buddha.* Berkeley: University of California Press, 2005.

Baas, Jacquelynn, and Mary Jane Jacob. *Buddha Mind in Contemporary Art.* Berkeley: The University of California Press, 2004.

Baldan, Diana, and Daniela Zyman, eds. *A Question of Evidence: Thyssen-Bornemisza Contemporary Art.* Cologne: Walther König, 2009.

Beck, Tally, and Brian Wallace, eds. *Return to Lhasa: Second Annual Tibetan Art Exhibition at 789.* Beijing: Red Gate Gallery, 2008.

Becker, Lisa Tamiris, and Tamar Victoria Scoggin. *Waves on the Turquoise Lake: Contemporary Expressions of Tibetan Art.* Boulder: University of Colorado, CU Art Museum, 2007.

Benaim, Henri Stéphan. "Lhasa: New Art from Tibet," Exhibition review, Red Gate Gallery, Beijing. In *ArtAsiaPacific* 56 (2007).

Bhabha, Homi K. *The Location of Culture.* London: Routledge, 1994.

Brauen, Martin. "Penba Wangdu and Tenzing Rigdol." In *ArtAsiaPacific* 61 (2008): 239.

Cherry, Deborah, and Fintan Cullen, eds. *Location.* Oxford: Wiley-Blackwell, 2007.

Chöpel, Gendün. *In the Forest of Faded Wisdom: 104 Poems by Gendün Chöpel, A Bilingual Edition.* Translated by Donald S. Lopez Jr. Chicago: The University of Chicago Press, 2009.

Connor, Lois. "Landscapes." In *ArtAsiaPacific* 61 (2008): 178–179.

Dinwiddie, Donald. "Gonkar Gyatso: Contours of Identity." In *ArtAsiaPacific* 63 (2009): 132–139.

Dissen, Rosemarijin, and Louise Thomas, eds. *Tibet Art Now: On the Threshold of a New Future.* Amsterdam: e=mc2 Publishers, 2009.

Gavin, Francesca. Introduction to *Tenzing Rigdol: Experiment with Forms.* London: Rossi & Rossi Ltd., 2009.

Gyatso, Nathalie. *Gonkar Gyatso: La Peinture Tibétaine en Quête de sa Propre Modernité.* Paris: L'Harmattan, 2005.

Harris, Clare. "Encounters in Intercultural Spaces: Gonkar Gyatso and Peter Towse." In *Oh! What a Beautiful Day: Peter Towse and Gonkar Gyatso's Shared Visions.* London: Anna Maria and Fabio Rossi Publications, 2006.

———. "Gonkar Gyatso: From Lhasa to London." In *ArtAsiaPacific* 50 (2006): 110–113.

———. "The photograph reincarnate: the dynamics of Tibetan relationships with photography." In *Photographs Objects Histories: On the Materiality of Images,* edited by Elizabeth Edwards and Janice Hart. London: Routledge, 2004.

Ivy, M. "Modernity." In *Critical Terms for the Study of Buddhism,* edited by Donald S. Lopez Jr., 311–331. Chicago: The University of Chicago Press, 2005.

Jansen, Gregor, Wonil Rhee, and Peter Weibel, eds. *Thermocline of Art: New Asian Waves.* Ostfildern: Hatje Cantz, 2007.

Jia, Lei. *Contemporary Tibetan Paintings.* Beijing: China Intercontinental Press, 2001.

Lachman, Charles. "Art." In *Critical Terms for the Study of Buddhism,* edited by Donald S. Lopez Jr. Chicago: University of Chicago Press, 2005.

Li, Xiaoke. *Tibet: The Colorful Chain from the Snowland Tibet Contemporary Art Exhibition.* Beijing: Tibet Contemporary Art Exhibition, 2004.

Maggio, Meg. "Why Go to Tibet?: Qiu Zhijie in Shangri-La." In *ArtAsiaPacific* 57 (2008): 120–125.

Martignoni, Rossella, ed. "Gonkar Gyatso." In *Making Worlds: 53rd International Art Exhibition,* 74–75. Venice: Fondazione La Biennale di Venezia, 2009.

Ng, Elaine W. Introduction to *Kesang Lamdark: Plastic Karma.* London: Rossi & Rossi Ltd., 2008.

Norbu, Thinley. "Art." In *Magic Dance.* Boston: Shambhala Publications, 1998.

Raffel, Suhanya. "Gonkar Gyatso: Trouble in Paradise." In *The 6th Asia Pacific Triennial of Contemporary Art,* 88–89. Brisbane: Queensland Art Gallery, 2009.

Reynolds, Valrae, et al. *From the Sacred Realm: Treasures of Tibetan Art from the Newark Museum.* New York: Prestel, 1999.

Rigdol, Tenzing. "Over the Tanggula Pass: Liu Xiaodong's Paintings of Tibet." *ArtAsiaPacific* 58 (2008): 80–81.

Rimac, Melissa. "Tibetan Religious Art." In *ArtAsiaPacific* 22 (1999): 59–63.

Rossi, Anna Maria, and Fabio Rossi, eds. *Consciousness and Form: Contemporary Tibetan Art*. London: Anna Maria Rossi and Fabio Rossi Publications, 2005.

————. *Dedron: Nearest to the Sun*. London: Rossi & Rossi Ltd., 2009.

Sangster, Leigh Miller. Introduction to *Tibetan Encounters: Contemporary Meets Tradition*. London: Rossi & Rossi Ltd., 2007.

Stevenson, Mark. "Art and Life in Amdo Reb gong Since 1978." In *Amdo Tibetans in Transition: Society and Culture in the Post-Mao Era*, edited by Tony Huber. Leiden: Brill, 2002.

Stoddard, H. "The Development in Perceptions of Tibetan Art: From Golden Idols to Ultimate Reality." In *Imagining Tibet: Perceptions, Projections, and Fantasies*. Boston: Wisdom Publications, 2001.

Tashi, Tsewang. "The 20th Century Tibetan Painting." In *Proceedings of the 10th International Association of Tibetan Studies*, Oxford. (Forthcoming).

Gluckman, Eliza. "Tibetan Contemporary Art: Beyond the Cultural Mask." *ArtAsiaPacific* 57 (2008): 126–131.

Tingley, Nancy. *Buddhas*. Petaluma: Pomegranate Communications, 2009.

Wallace, Brian, ed. *Lhasa: New Art from Tibet*. Beijing: Red Gate Gallery, 2007.

Yoon, Janet. "Gonkar Gyatso." In *Mapping Identity*, edited by Carol Solomon and Janet Yoon, 16–17. Haverford: Haverford College, 2010.

ONLINE ARTICLES AND RESOURCES

Art Radar Asia: Contemporary Art Trends and News From Asia and Beyond. http://artradarasia.wordpress.com/category/artist-nationality/tibetan/

Avery, Dan. "Own This City: 3 Questions for ... Tenzing Rigdol." Time Out New York. http://www.timeout.com/newyork/articles/own-this-city/21423/3-questions-fortenzing-rigdol

Davis, Deryl. "Reaching a Peak: New Tibet Center Showcases Works by Three Exiled Artists." Mechak Center for Contemporary Tibetan Art. http://www.mechak.org/reaching_peak.html

Dhondup, Yangdon. "Some Thoughts on Contemporary Tibetan Art." Mechak Center for Contemporary Tibetan Art. http://www.mechak.org/some_thoughts_on_contemporary_tibetan_art.html Gendün Chöpel Artists' Guild. http://www.asianart.com/gendun/index.html

Heimsath, Kabir Mansingh. "Untitled Identities: Contemporary Art in Lhasa, Tibet." Asianart.com. http://asianart.com/articles/heimsath/index.html

Mannion, Shelley. "Seeing Tibetan Art Through Social Tags: A Study of how young Tibetans respond to Tibetan Cultural Iconography." Archives & Museum Informatics. http://www.archimuse.com/mw2008/papers/mannion/mannion.html

Raw Art Weblog. http://rawartint.wordpress.com/2008/01/04/rossi-rossi-presents-tibetan-artist-norbu-tsering-akn-nortse/

Rossi & Rossi Ltd.: Catalogues. http://www.rossirossi.com/publications

Scoggin, Tamar. "Report From Lhasa." Mechak Center for Contemporary Tibetan Art. http://www.mechak.org/report_from_lhasa.html

————. "Unexpected Lineages: From Traditional to Contemporary Tibetan Art." Mechak Center for Contemporary Tibetan Art. http://www.mechak.org/unexpected_lineages.html

Simons, Craig. "At a Gallery in Lhasa, Tibet Joins Art World." The New York Times. http://www.nytimes.com/2004/11/22/arts/design/22tibe.html

Vora, Swapna. "Tenzin Rigdol's Mandala: Particles of Prayers." Asianart.com. http://www.asianart.com/articles/vora/rigdol/index.html

Colophon

Published on the occasion
of the exhibition
"Traditions Transformed:
Tibetan Artists Respond,"
organized by the Rubin Museum of Art.
Rubin Museum of Art,
New York, NY
June 11–October 18, 2010

Publication
Editor: Elaine W. Ng
Creative Director: Joon Mo Kang
Project Manager: Hanae Ko
Manuscript Editor: HG Masters
Copyeditor: Michael Lacoy
Proofreaders: William Pym and Ashley Rawlings

Design: Peter J. Ahlberg / AHL&CO
Production and printing: ArtAsiaPacific

First published by:

ArtAsiaPacific Publishing, LLC
245 Eighth Ave #247
New York, NY 10011
Tel. +1 212 255 6003
Fax. +1 212 255 6004
www.artasiapacific.com

And:

Rubin Museum of Art
150 West 17th Street
New York, NY 10011
Tel. +1 212 620 5000
Fax. +1 212 620 0628
www.rmanyc.org

Additional support for this publication
has generously been provided by Trace Foundation, New York

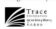

Printed in Hong Kong
Distribution
ISBN: 978-0-9845625-0-3